About the Author

R. BROWNELL McGREW has been a westerner since leaving his birthplace, Columbus, Ohio, in childhood. After completing four years of study on full scholarships at Otis Art Institute, Los Angeles, he painted portraits, religious subjects, and did some matte shot and scenic work for motion picture studios. Winning the John F. and Anna Lee Stacey Scholarship in 1947 enabled him to devote many months to intensive study of landscape, particularly the California Sierra. He later focussed his attention on the desert, whose harsh, demanding subtleties led him to a life-long preoccupation with the Southwest and its peoples. McGrew is married and has three daughters. He is one of the original members of the National Academy of Western Art and holds honorary membership in other professional organizations. He is an active layman of the Lutheran Church, Missouri Synod.

R.Brownell
McGrew

LAGUNA BEACH MUSEUM OF ART
PRESENTED BY THE THUNDERBIRD FOUNDATION
AUGUST 1978

THE LOWELL PRESS/KANSAS CITY

FIRST EDITION

Danny Davey's Thunderbird Foundation

"Not a handout, but a hand up"

It has been more than thirty years now since Danny Davey, a young seaman just returned from aircraft carrier duty in World War II, came across several other veterans on a hunting trip in Arizona. Those veterans, all Indians, Danny discovered, had come home to much less than he.

What began then as a generous gesture to a few native American families, trying to live off barren land "given" to them by a government their ancestors could not understand, has grown today into The Thunderbird Foundation, a non-profit organization involving thousands of people who hope to help Danny help the Indian better his life.

How did it start? By returning again and again to "help just one more family," says Danny, now a United Parcel Service deliveryman. What began as a simple Thanksgiving dinner for three Indian families has grown to an event looked forward to every November by more than 5,000 Indians. Most of them must start before daybreak and walk or ride on horseback over snow-covered terrain more than fifty miles just to get there.

Danny does not consider these Thanksgiving dinners as "charity." He knows it is hard to "pull yourself up" when the fight for mere physical survival is a daily battle. Life on the reservation is far from easy. There are none of the comforts of home, none of the "necessities" city and most country folks take for granted. Water is a precious and expensive commodity, as is the wood needed to make life in a hogan endurable once the snow starts to fall.

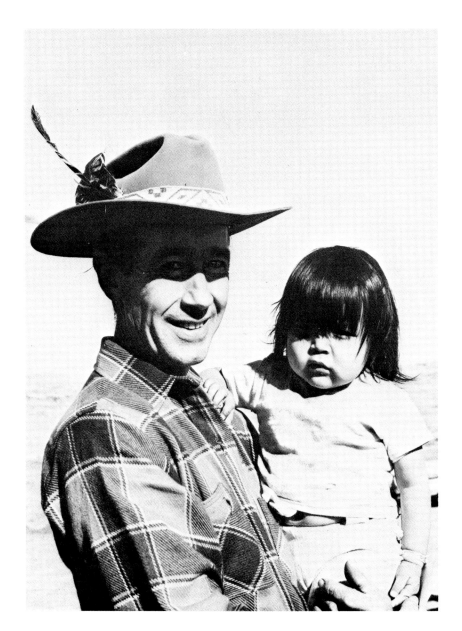

Little Danny
Photo by R. B. McGrew

Big Mac
Photo by Robert Lougheed

Danny's Thunderbird Foundation has been able to meet some of the Indians' basic needs. The organization does not offer a handout, but a hand up for the great people it serves, and, through the foundation, Danny Davey hopes to provide educational scholarships for Indian children, especially in the field of art, to send Indian children to art school.

"Danny Davey *is* The Thunderbird Foundation, and The Thunderbird Foundation is Danny," says Harold J. (Bud) Hohl, supervisor of technical services at Orange Coast College, a former pilot for the U.S. Marine Corps and one of the non-profit organization's staunchest supporters.

Danny's dedicated helpers range from members of Coastline Post 3536, Veterans of Foreign Wars, whose members helped financially underwrite his Thanksgiving caravans prior to organization of The Thunderbird Foundation, to the thousands who read "The Trouble Shooter" column in *The Register* (Santa Ana, California) where Danny's frequent pleas for assistance are aired. They include ladies in modest circumstances who pool their trading stamps to buy some of the things "Danny's Indian friends need" to top ranking business and professional men and women, entertainment and sports personalities, and such outstanding talents as R. Brownell McGrew whose vivid and perceptive paintings of a great people are the subject of this book.

The American Indian is blessed to have Danny Davey as a friend. So are those of us who have a chance to share Danny's dream.

Dorothea Bellisime
for "The Trouble Shooter"
The Register, Santa Ana

On April 30, 1978, as this volume was being prepared for the press, the national governing board of the Daughters of the American Revolution awarded its Medal of Honor to Danny Davey. It is the highest award given by the body to a native-born American and recognizes in the recipient outstanding qualities of leadership, character, and devoted service to others. The medal is a rarely bestowed honor indeed, but all who know Danny and his work with Indians are happy in the conviction the accolade could not be given to a more deserving individual.

Table of Contents

Except where otherwise indicated, text is by B. McArthur.
All paintings not otherwise attributed are from the artist's collection.

COMMITTEE FOR THE EXHIBITION

Danny Davey Mickey McArthur

Foreword

It is not often that a painting of a human face bespeaks the beauty and character of the artist, subject, and viewer. Since my first exposure to the art of Brownell McGrew, I have seen his portraits of ranchers, debutantes, bishops, and at least as many Indians as General Custer—executed in oils, pastels, crayons, charcoal, and pencil-sketched. Generally, the visual impact is instantaneous . . . the hallmark of "masterpiece" is constant and unmistakable.

Brownell McGrew paints great paintings because he has an inborn awareness of the greatness of God, and he is incessantly possessed of a great feeling and reverence for life and the creatures of the earth.

He is a man of great physical structure, blessed with above average qualities of mind, spirit, and competence dedicated to highest standards of excellence. He is a gentle man of intense quietness—not withdrawn, troubled, subdued or repressed—only serenely, intently quiet.

His art has reached a peak of supreme development which reflects his attitude and sensitivity toward the beauty or force of the Indian karma and environment.

He portrays the Indian with dignity, respect, and a degree of credibility and understanding—the product of many years of first-hand knowledge of Indians, their land, and whatever Great Spirit lives in the Southwest. He is reverently dedicated to expressing his love for perfection of form and derives great satisfaction from his efforts to cheer, console, and ennoble the life of his Indian friends.

Sincerely and with deepest admiration and love,

Joe Alacer

Laguna Beach Museum of Art

BOARD OF DIRECTORS

ACKNOWLEDGMENT

I wish to express my appreciation to The Thunderbird Foundation board members and the Board of Directors of the Laguna Beach Museum of Art for making this exhibition possible. I especially would like to thank Mr. R. Brownell McGrew for his assistance in this exhibition of his work and to Mr. M. McArthur for bringing the idea of this exhibit to me.

Tom K. Enman
Director

SOLI DEO GLORIA

Acknowledgments

Our grateful thanks to all the owners of paintings and drawings whose generous cooperation made this exhibit and its catalog possible.

To Mickey and B, who said, "You're going to need some help with this project," and then, unstintingly, supplied it.

To Harold Lindell for his help and advice in the planning stages.

To Payson Lowell and all his co-workers at The Lowell Press; not only for superb workmanship, but for cheerful patience under a barrage of artistic criticism, not to say cantankerousness. A special thank you to Dave Spaw, Barbara Forsman, and the skilled press crew supervised by Howard Constable and Fritz Thoele.

To Jerry Sellinger for his painstaking attention to all the artist's requests in the color separations.

To Bill and Stephanie Dickerson at O'Brien's Art Emporium for taking care of at least a thousand details connected with assembling the paintings.

To Bill and Gwen O'Brien for—how many years?

To Joe Stacey for kind words, over and over again.

To "The Trouble Shooter" of *The Register*, Santa Ana.

To Bud Hohl and his helpers at The Thunderbird Foundation.

To Gary Avey at W. A. Krueger Company for supplying technical assistance.

To Norm Moldenauer and Earl Secor for their enthusiastic help.

To Tom Enman, the directors, and the staff of the Laguna Beach Museum of Art.

To Don Williamson and his staff at the Pageant of the Masters for coordinating a presentation of *The Dinneh* with this exhibition.

To the galleries who have assisted: Trailside Galleries (Jackson, Wyoming), Carson Gallery of Western Art (Denver), and Kennedy Galleries (New York City). And to Ginger Renner and Rhea Carlson for their help in tracing early paintings.

To Ruth and Aaron Cohen of Guidon Books, Scottsdale, for experienced counsel.

To Chet and Kay and Bryan and Steven Johns, for invaluable, loyal, practical, and affectionate help.

To Peggy Davey, for grace under pressure.

To Gail, Becky, and Jill, for always understanding that the studio came first.

To Bill, John, and Larry for consoling G., B., and J.

And meanwhile, back at the ranch, to Larry Armstrong, who keeps everything from the tractor to the canary bird running smoothly.

List of Paintings and Drawings

Introduction

It was my very good fortune to run across R. Brownell McGrew's paintings at a gallery in Palm Desert, California, in 1956. They were absolutely phenomenal in that they portrayed nature as I had never seen it portrayed, and his unusual technique was fascinating. As I look back on that occasion, I realize that they were not so much landscapes as they were "portraits" of rocks and desert flora.

Determined to find the creator of these magnificent paintings, I traced the artist to a little school in Palm Springs. I had already envisioned him as a fragile and scholarly type and was somewhat surprised when he was introduced to me. With his crew-cut hair, burly build, and powerful hands, he appeared to look more like an ex-marine or seabee. I was able to prevail upon "Brownie," as I call him and have always called him from the beginning, to allow me to represent his work in Arizona.

Returning to Phoenix, we began exhibiting the four paintings that were the initial consignment from Brownie. These were subsequently returned to him as gallery sales were quite slow at that time of year, and the paintings were not really generating much interest.

In November of that same year, Brownie graciously sent me nine new paintings ranging in size and price from 8 x 10 at sixty dollars to a beautiful 30 x 40 painting at six hundred dollars. The next month we moved into a new and much larger gallery in Scottsdale where we felt there would be a much more receptive market. The new location allowed us to generate more interest due largely to the fact that we were able to reach some of the people in the inns and hotels—the so-called "Turista." However, our clientele was quite reluctant to invest two or three hundred dollars in a painting by a relatively unknown artist.

Finally, the time came when I had to recognize the facts of life. I just did not have the buyers to sell these beautiful landscapes. On April 24, 1958, I wrote Brownie a

letter stating that lack of interest and sales were not beneficial to either gallery or artist and that I was regretfully returning his paintings. He still gets a chuckle thinking about this and still has the original letter. Because things have changed so drastically, it really is quite humorous. Today these landscapes could sell for fifty times the original asking price! So time passes.

In due course, namely the end of September, 1960, I was in Laguna for the annual Arts Festival. As I walked in, a large painting at the end of the display caught my eye. Literally fantastic, it was different from anything else I had seen. The painting, which was worthy of the great masters, depicted a group of Navajo Indian children in a wagon and was titled—appropriately—*In the Wagon*. It was a magnificent work of art and much to my surprise was signed R. Brownell McGrew. I immediately telephoned Brownie and asked "Wow! When did you start doing figures?"

Through the influence of Jimmy Swinnerton, one of the great early painters of the desert, Brownie had become interested in depicting American Indian life. This was furthered by Chuck Shelton of *Desert Magazine* in Palm Desert, California, who was interested in reproducing the artist's paintings in his magazine and eventually publishing prints for the market. This later proved to be more expensive than practical and was abandoned. However, Brownie had found his forte—a profound discovery which would change his entire life. As often happens, an idea is right and is picked up and carried away like a cyclone. Brownie

had always been a figure painter, something I did not realize.

In the Wagon, the painting which had so enamored me in Laguna, was shipped to our gallery in Scottsdale and placed in the front window. It was sold the same day to a gentleman who nearly caused a traffic accident when he spotted it out of the corner of his eye and quite suddenly swerved into our parking lot.

It was during this period of painting, sketching, and living with the Indians that Brownie developed a love and compassion for these Americans. His brush depicted the Navajo and Hopi customs, rituals, and lifestyle. His portraits reveal their anguish and frustration as well as their joy and celebration. It was also during this period that I realized what a complex and sensitive man Brownie is—a man very much enveloped in his religion. Having dealt with artists a good part of my life, I found it unusual that he was almost totally detached from the economic standpoint of his art. He painted because he had to paint—it was his heart and soul.

McGrew has won so many honors in all parts of the country, they are too numerous to mention. When I first accepted the challenge to write this introduction, I had no idea what it would entail. I now find that there is no end to what I would like to and could say about R. Brownell McGrew. But after a lifetime in the fine art business, it is my studied opinion that the great artists possess a divine gift at birth. If they have it, they can polish it. If they do not, they can study from the greatest masters, and all they become are excellent craftsmen. Now, one of these great artists is about to tell about himself in word and picture. It is about time this has been done.

With respect and admiration,
William V. O'Brien
President
O'Brien's Art Emporium

"no man is an island"

Although public recognition was slow, there was never any doubt among painters that McGrew was something out of the ordinary. When he finishes a passage, it is like a successful line of music or poetry: seeming so effortless, so inevitable, that it takes another artist to discern the punishing effort which achieved that effect. Many artists helped him: Thomas Leighton, who arranged shows for him early on; Frederic Whitaker, N.A., who wrote, for *American Artist*, one of the finest critical studies ever done; Robert Wood, who bought a McGrew painting when almost nobody was buying them; Jimmie Swinnerton; others too many to list, who encouraged with generous understanding and insight.

His teachers, notably Lester Bonar and Ralph Holmes, had no difficulty in recognizing what they were dealing with. I remember going one night in the early 1940s to the Los Angeles County Art Museum to see Ralph Holmes do a demonstration lecture. We had no car and had to wait for a streetcar and then walk a distance, so we were late. I recall tip-toeing across big, empty marble floors to reach the lecture hall where Mr. Holmes was holding forth in his usual effective way as he painted. He had his back to the audience, of course, and after a while he paused and turned around to make a point, catching sight as he did so of McGrew standing at the back of the hall. He stopped in mid-sentence, taken aback and oddly embarrassed. "Mac, have you been there listening to all this?" he asked. Mac was eager for Holmes to contin- ue painting, since it was the only time he had seen that fine teacher with a brush in his hand, his instruction being by precept and

not example. Holmes turned back to his canvas and made a few tentative strokes, then laid down his brush, turned back to the audience and announced that the demonstration portion of the evening was over—it was apparent that he was unwilling to paint with this pupil watching. McGrew always said it was about the greatest compliment he ever had.

An exhibition of paintings while McGrew was still in art school elicited a perceptive and prophetic comment from Herman Reuter in the *Hollywood Citizen-News:* "McGrew is a young technician whose skill verges on the dazzling. His dexterity derives from that rarest of all gifts, a kind of instinctive, curious 'feel' for paint. The gods do not grant that gift to many. With it, a painter may become a master, if he has something to say." McGrew found his "something to say" when Jimmie Swinnerton, always generous to younger painters, introduced him to the Hopi and Navajo reservations. Something of the same sort must have happened when Degas saw his first ballet dancers. Man, medium, and models formed an explosive amalgam which has been shooting off pyrotechnic displays of mastery ever since. Jimmie would have been proud of this show.

Every artist needs appreciators—people like Uncle Ted and Danny Davey and Mickey McArthur and Harold Lindell. In 1946 Harold came home from Iwo Jima, not too sure what he wanted to do for himself, but very sure what he wanted to do for his friend the struggling painter. For more than thirty years he has carted paintings to exhibits, made crates, made phone calls, written letters, lent every effort (and sometimes every dollar) to help. He is still helping. His name as Patron for this show is by no means a purely honorary listing.

In 1960 McGrew sold ten paintings, a rec-

ord-breaking year. 1961 was not quite so good, and 1962 saw only seven paintings sold, but one of those, foundation stone of a prestigious collection, went to Mickey McArthur. He is a charter member of the exclusive club who always believed in McGrew, and he has continued to buy paintings until his is now the largest collection in the country. He is one of the greatest appreciators of them all.

In 1963 Mickey McArthur and Harold Lindell each bought a painting, joining fifteen others willing to back their confidence in the artist with cash. The fact that their paintings are now worth ten times what they paid for them no doubt provides some satisfaction, but, now as then, their principal interest is that they love looking at the paintings and think they are beautiful. An artist cannot receive greater tribute than that.

<div align="right">Ann McGrew</div>

as the artist sees the world

The Indians call him "Big Mac." He comes to them with respect and lives amongst them as few white men do. They ask his help, his goodwill and his friendship. He paints from an understanding of man's soul, hence there are no imitators.

The paintings evoke feelings of another time and a different world view. This can be summed up in a review dated 1821 of a new novel by Sir Walter Scott. The reviewer is John Leycester Adolphus, who comments about Sir Walter's books:

"They furnish a direct and distinguished contrast to the atrabilious gloom of some modern works of genius, and to the wanton, but not artless, levity of others.

"They yield a memorable (I trust immortal) accession to the evidences of a truth not always fashionable—that the mind of man may put forth all its bold luxuriance of original thought, strong feeling, and vivid imagination, without being loosed from any sacred and social bond, or pruned of any legitimate affection; and that the Muse is indeed a heavenly goddess, and not a graceless, lawless runagate."

McGrew's discomfort with the twentieth century is implicit in his paintings. They depict neither conflict, mechanization nor Anglo influence. Pictured are the materials of earth: wood, leather, silver, fur—not the products of technology.

These paintings are evocative in four dimensions: in the height and depth and breadth

of the desert country, and in the backward stretch of time. They cry out,
"Look and see. There is beauty all around us—do not miss it. Creation is
infinitely lovely—do not pass by unseeing."

"The big man talks gently, almost reluctantly, as if he thinks that
painting, not speech, was meant to be his way of communicating.
Whenever a pause appears in conversation, he doesn't press the point.
He just waits until something happens in his or in my mind." This is
a statement by a young Norwegian writer, Elizabeth Young. She tells
it well.

From the artist:

"Let us give thanks that there are still places
in the land where a lithe horseman, his long
black hair in a chongo knot, gallops his pony
over endless miles of sun-baked earth to
his simple home where a juniper fire
sends perfumed tendrils of smoke into the
quiet sky."

...and as the world sees the artist

All art is an attempt on the part of the artist to communicate to others his excitement, delight, disgust, horror, joy, or whatever emotion he is feeling. In McGrew's case this communication is two-way. People write to him constantly to convey their response—sometimes they write questions, and the communication goes on. Sometimes these letters lead to meetings and to friendships. Some letters are from children—some from the very old. Each one receives an answer.

from Bellflower, California:

"I'm 89½ and my husband died two years ago. If I didn't have a very personal friend in Christ, life would be lonely indeed. I was born in a sod house on the western plains of Kansas. I am thankful I can still see the work of your hands and heart. You bring us ancients much joy!"

from a college student in Idaho Falls:

"If I were asked to name the one artist I most admire I would name you. I believe that you paint with humility and deep respect for your subjects and because of the greatness of your humanity the greatness of your paintings is obvious."

from a sixth grader:

"It was very interesting, especially your paintings of the Indians' faces. I was very impressed with them, they were my favorites. I really like your paintings and the colors are what set them off. One day I'm very sure I'll buy one."

from an even younger child:

"The pitcher I liked best was the indian it was really good the hold thing is really good."

from Missouri:

"Thank you, sir: your paintings have reminded me how homesick I am for the desert, and how I can never wholly leave it. Last night I dreamed of

mesquite, whose odor I thought I had forgotten. For that I thank you. Tonight I am gathering all my courage to write to you."

from a Plains Indian:

"Your paintings make me proud to be an Indian."

from a teenager:

A moving comment was reported by Barbara Perlman, reviewing for *The Arizonian:*

"A teenage boy walked into [the gallery]. He stopped in front of *Old Ones Talking,* a picture of wizened elders in naked contemplation of mortality. 'That's just what they look like,' he exclaimed in the rather too loud, blandly callous tone of adolescence. 'Old and ugly.' Then his voice trailed off in perplexity. 'And beautiful, actually.' "

from a pathologist:

"I expect when I expressed my admiration for artists I was thinking of the commitment which I expect you have made . . . perhaps not unlike the one I have for what I do."

from a collector:

"Just received forty thank you letters from the third grade children at Reynolds School, for making the gallery available for them to visit. Their teacher wrote also and said she has taken children to the gallery for the past five years and she says: 'The two originals by R. Brownell McGrew are our all-time favorites. My classes always stand hushed and almost reverent as they take in the expressions of the two Navajo groups.' To me it was a pleasure to receive the letters and to know how your paintings impress the children."

And always, the letters and cards, almost every day, from the Indians:

"Dear friend Big Mac, first I like excuse myself for this messy

letter. Because of that is I am in a hurry today. My sister is in Flagstaff babysitting for one of the cousins. Me I'm gone work here at Hard Rock Mission. Try to visit us soon, everybody wants to see you again, also they miss you a lot. We moved because _____ he always got drunk and come to our house and cust us out and we don't like drunkers to come to our house. I am getting sleepy so I better say good-night until I heard from you again.''

⊚ ⊚ ⊚

"Dear McGrew, before I say any words again I would like to entertain ourselfs by saying a nice hello to you and your familys. Well, for the climate it is just so bad, everyday. I just hate that mudding, snowing. But we are all just doing fine and the people around our home are fine too. The kids are just wondering why you don't come. We tell them, because of the bad climate he doesn't come to see you. They don't understand. So answer soon.''

⊚ ⊚ ⊚

"Dear friend, This fine morning I just wanted to write to you again. I want to tell you something. Thats about me going to a Bible school to Colorado. I think maybe you could help me out. My ma and dad they don't really care for me any more. I am just so worry about that sometimes I just feel like killing my self. But I just can't do that, so I got no place to go but to the Lord. Things are quite change in my life. Hope I can hear from you soon, good bye, good luck, God bless you.''

⊚ ⊚ ⊚

"Dearest friend Mac, Well I just got your letter last week ago and it sure did cheer me up for a while and we were

very happy to hear from you. We all just say a nice big fat hello to you and Ann. And for my uncle you ask about, he is not an old man yet. And about the rug I am gone weave for you, the cost of the rug it up to you when you see it. And for the climate is just a little bit cool and no snow. And ma just said hello to you. I think this will be all now. I never had a friend like you never until now.''

<center>◎ ◎ ◎</center>

"Dear Big Mac, Our goat born a baby goat. And my sister has a new baby too. When you come next time can you bring us some shoes? Because we doan want to be barefeeted.''

<center>◎ ◎ ◎</center>

"Dear McGrew, This morning I would like to write a letter to you and say a nice hello to you well I'm doing fine with everything. Last week my father horse died at the squaw dance. Well we are all out of everything. And there is a carnival coming on October 19. I think of you that you are the only one that can help me with everything and I think you as a father. Good-bye and God bless you.''

9

"Dear sir, To begin with my name is _____ and I've never met you but I've heard a lot about you and I would be grateful to meet you. At this time of the month most of the people of the village are all busy, so I'm writing for my mother-in-law. She's making piki and trying to finish with her plaques. She is so busy that she asked me to write to you. We'd like to inform you that the Home Dance is on the 24th of July and we'd be pleased if you would attend. That way it would give me a chance to have the pleasure of meeting you. I'm not much of a letter writer so I'll conclude here."

◎ ◎ ◎

"Dear Big Mac, How are things coming along? We have been wondering what happened to you. The kids have been asking, too. Things out here are going okay. Sometimes times are hard and rough but we're making through. We're going to have another baby in the next month, but _____ hasn't been working this past year and I'm afraid we won't have enough baby clothes to clothe our baby. We have a cornfield and so far the corn are getting taller every day. Pretty soon they'll be riped. Maybe if you come when they are ripe you can get to eat some of our corn. Also there's watermelon, canilope and squash. So come out and see us. We'll be looking forward to your coming."

◎ ◎ ◎

"I guess I appreciate your kindness much since you are the only friend that still think of us, others are all stop coming for some reason, but its ok. So we'll always friends. Bring your wife some time. Bye bye now."

◎ ◎ ◎

"Well, McGrew, I guess this is all I got to say, so I'll close here with our best wishes, may the Lord bless you all.

PS: Thanks for your helping the Indians."

(a journalist puts it another way)

About those fellows who kick the 9 to 5 grind and travel the dusty wagon tracks to the hogans and sheep watering holes of Arizona's northland . . . the ones who get themselves far, far away from asphalt highways in favor of the byways....

There's something about them, you know. Something that can inspire green-eyed envy and avid fascination amongst the rest of us.

Maybe it's because they are self-sufficient, eye-on-the-mountain kind of guys who sometimes, somehow manage to bring back, even to the cities, their own love of the back country and of the remoteness, simplicity, and freedom of their Indian friends.

Some traders are like that. So is the artist who writes. The one who writes that everything beloved about the back country and Indians "makes me an alien in our homogenized, plasticized, die-stamped, cliche-ridden uncivilization."

That's R. Brownell McGrew, whose portraits of Navajos and Hopis are so alive you want to reach out and touch the turquoise pawn necklaces around their necks.

Meet him for the first time at an art show opening when he's all duded up in a city suit, and you meet a pleasant, modest, soft-spoken, mannerly fellow who doesn't have much to say—except pleasant, modest, soft-spoken, mannerly things.

But meet him the next day when he's dressed in the world's most faded jeans and dustiest boots, and he's got his ham-hand wrapped around a coffee mug and his pickup revved up for a junket to the back country—and WHEE!

You know you've just encountered the big daddy of all the eye-on-the-mountain types and that he's just about to tell you what he finds on the yonder side of those far away mountains where he knows the land of heart's ease and images that never tarnish, never mind how many times he revives them in his mind's eye.

So . . . a gulp of coffee, a push at his hat, the comment that it's foot-in-mouth department when a white man talks about Indian life, but . . . and he begins:

"Take food. We go to the butcher shop and order a coupla pounds, never thinking in terms of animal life, nature, and the interdependence of God's creatures.

"Indians live with their sustenance all the time. When they slaughter an animal, it's a significant act to them that demonstrates man's dependence on other forms of life, and man's responsibility to nurture, care for, and be humane to lesser creatures."

Whites, he said, are so preoccupied with sedentary matters they skirt discussions of important things and talk of golf scores, autos, Howard Johnson restaurants, and the creature comforts that insulate them from undergoing any change in environment—any sense of adventure, hazard, or discomfort—even when they travel from one place to another.

Indians, he said, don't chase the clichéd rainbows that whites do, and their talk gravitates naturally—and pronto—to the philosophical, spiritual, and ideological bases of concern.

"They have a respect for Nature and meet it on its own terms; we whites feel that we can manipulate nature to our own ends, and any landscape is a fitting subject for compulsive engineering.

"The dysgenic factor in the white situation is an excessive preoccupation with making everything comfy. It's taken a glow out of our lives that we don't even know we've lost because we haven't kept in shape to enjoy the world as it is."

McGrew began keeping journals of his visits to the reservations simply to tell buyers of his paintings about the subjects. That's the kind of stuff that bowls over buyers of McGrew oils. (Just plain old viewers can sneak peeks of the stuff at O'Brien's Art Emporium in Scottsdale.) For writers, McGrew tosses verbal gut-grab-

bers about a velvet black nighttime in a Hopi village under a sequined sky. Here's the way he told it in his journal:

"As my eyes became accustomed to the surroundings, I could see there the skeletal arms of the kiva ladder flung beseechingly against the sky and just where the ladder plunged into the sacred room below, there was that faint reddish halation which signalled activity in the kiva, as men warmed themselves against the biting winter night.

"Then from the kiva came a thrilling sound, the deep muttering chant of priests singing in preparation for an approaching ritual. I stood looking at the faint glow that picked out a few edges on the top of the structure. The rumbling bass tones rose and fell, sending ancient song into the village night.

"There was something ineffably moving and primordial in the sound, carrying the mind back through the untold centuries, into the mists of time when the same deep, stirring tones called the ancestors of these and all men to look beyond and above themselves."

Maggie Wilson, *Arizona Republic*
Sunday, October 26, 1969

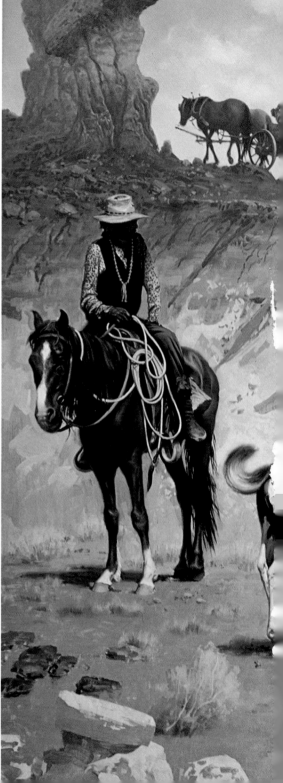

Plate 1. OFF TO THE TRADING POST, *oil, 38x60 in. Collection: Mr. and Mrs. Thomas L. Parker, Wyoming*

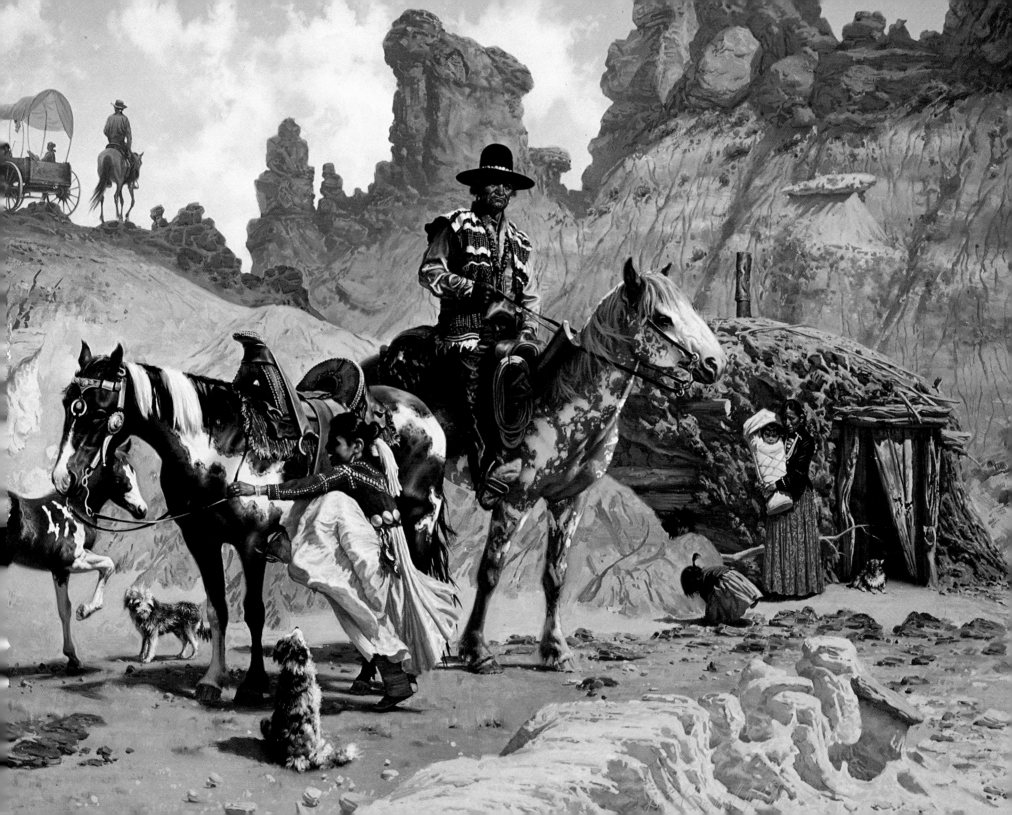

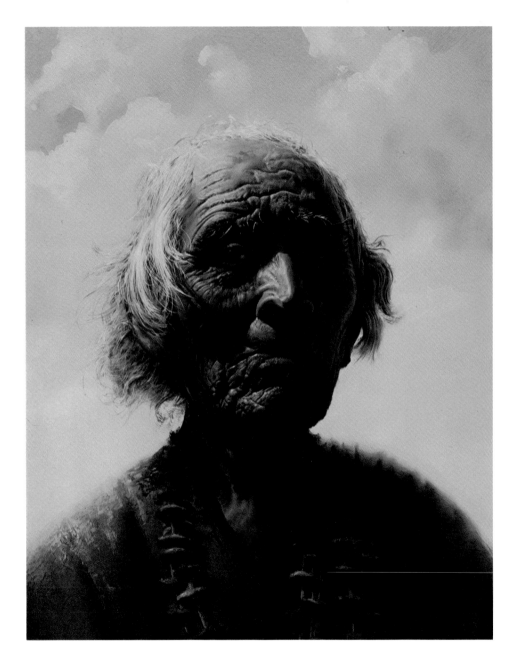

Plate 2. TUWAHOYIMA, A PRINCE OF THE HOPI,
oil, 20x16 in. Collection: Dr. and Mrs. Chester Z. Haverback,
Rockville, Maryland

16

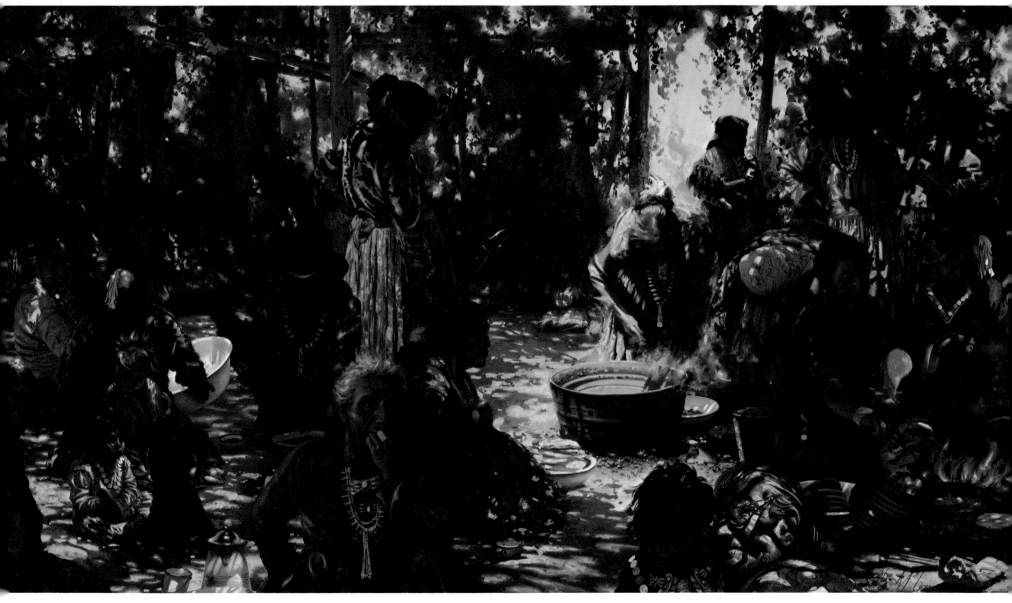

Plate 3. ENTAHL: IN THE COOKSHADE, *oil, 33x60 in. Collection: Mr. and Mrs. Warren B. Jones, Harlowton, Montana*

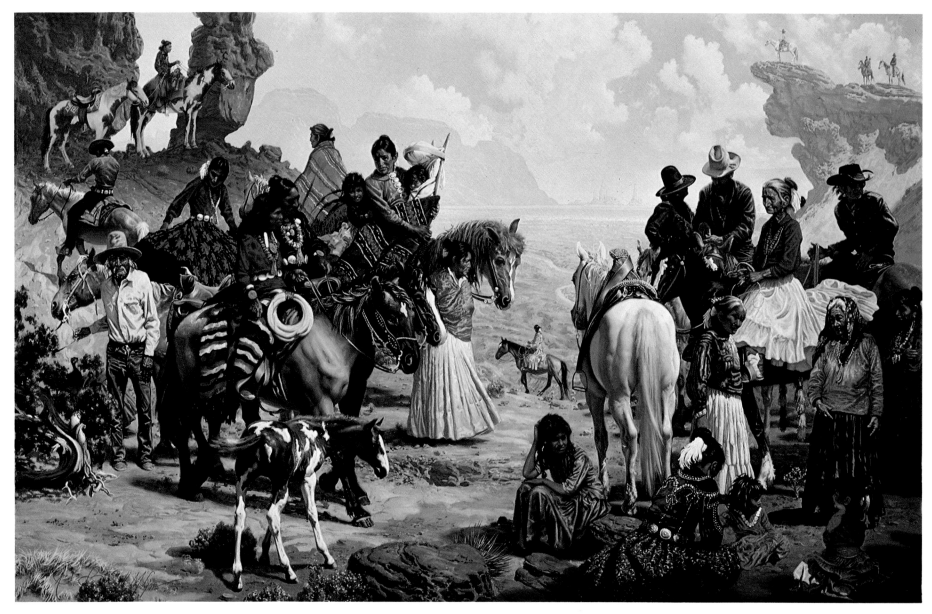

Plate 4. TSE LAHNI, *oil, 42x66 in. Collection: Mr. and Mrs. L. R. French, Jr., Midland, Texas*

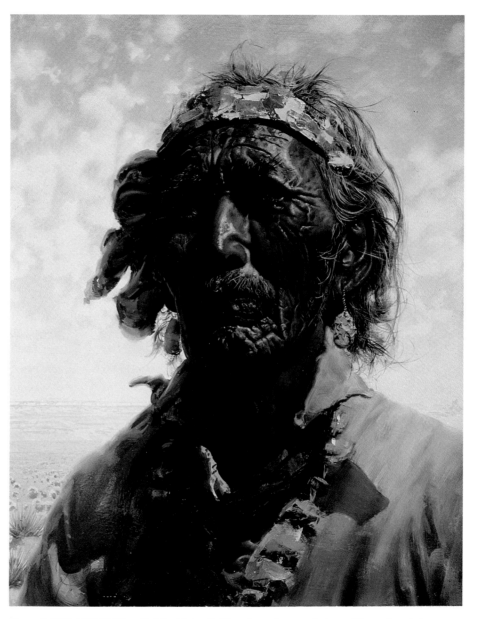

Plate 5. BIG THUMB, *oil, 20x16 in. Collection: Steven Johns, Phoenix, Arizona*

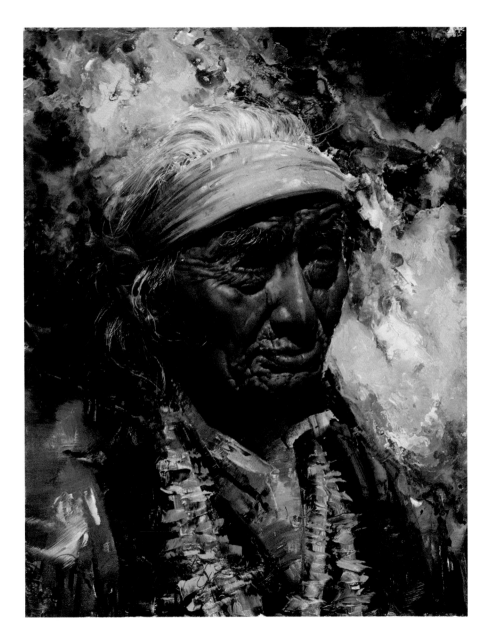

Plate 6. HASTI'-IN SPECK, *oil, 20x16 in.*
Collection: Stan Holuba, Bogota, New Jersey

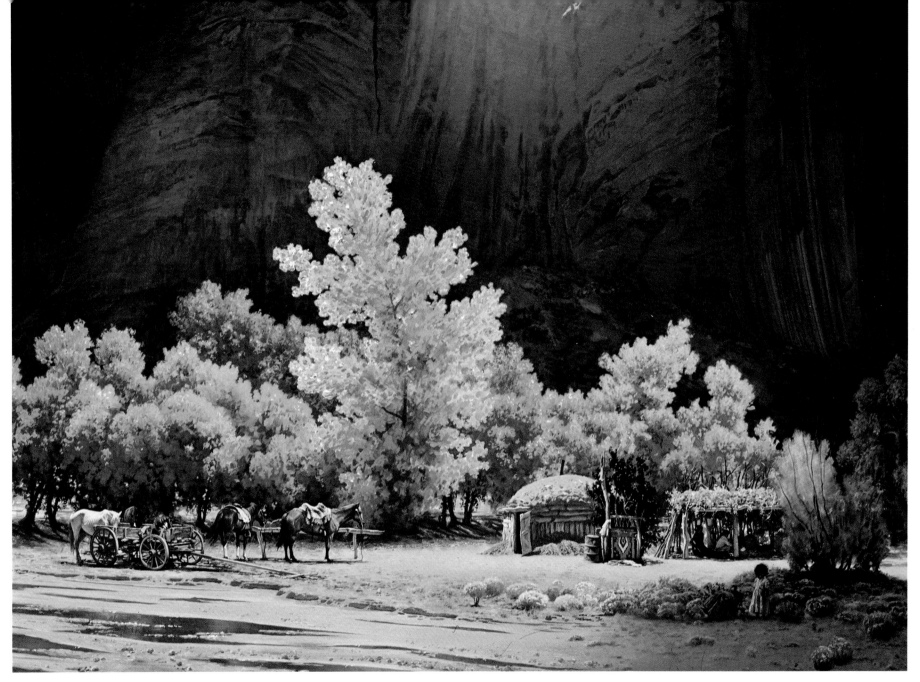

Plate 7. TSAYEI, *oil, 36x48 in. Collection: Mr. and Mrs. Thomas L. Parker, Wyoming*

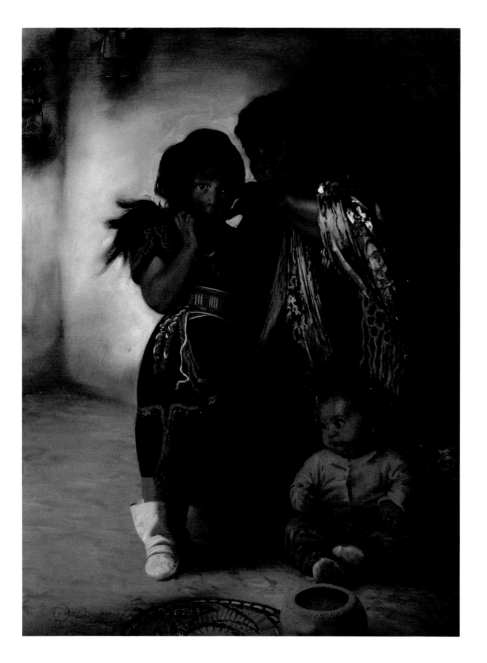

Plate 8. OFFUSSATARA GETS GUSSIED UP, *oil, 40x30 in.*
Collection: Mr. and Mrs. John T. Smith, Scottsdale, Arizona

Plate 9. TSOSIE AHZONIE, *oil, 24x20 in.*
Collection: Mr. and Mrs. Carl S. Carlson, Palm Springs, California

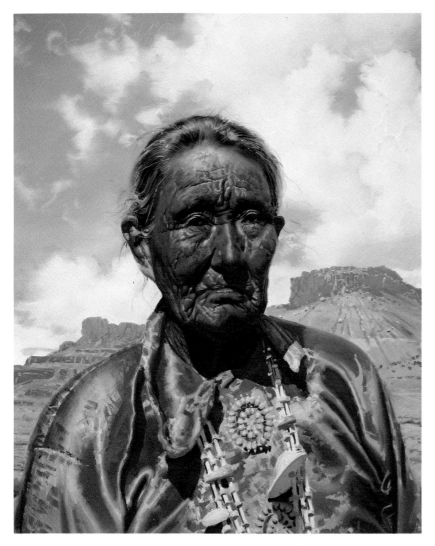

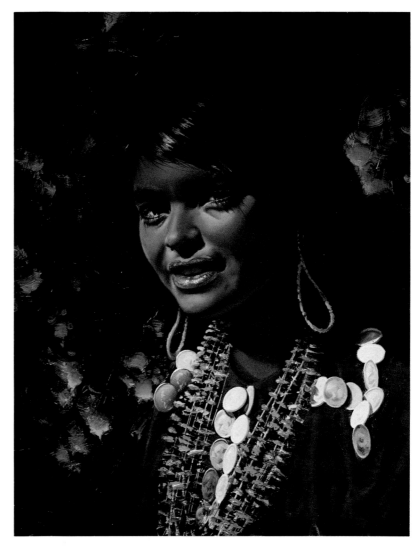

Plate 10. AHT-ED HOLTSOIE, *oil, 20x16 in.*
Collection: Mr. and Mrs. Chet Johns, Phoenix, Arizona

23

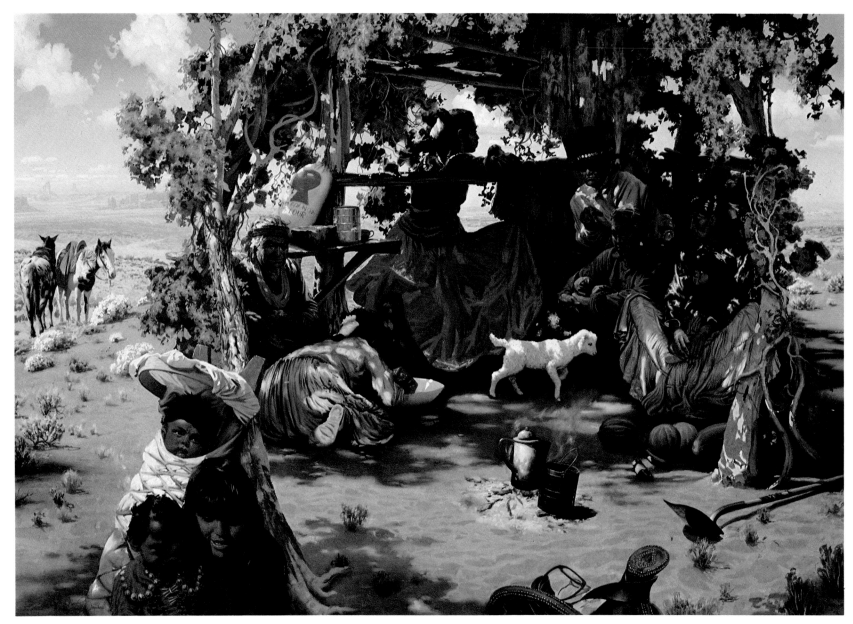

Plate 11. DOLCE FAR NIENTE, NAVAJO STYLE, oil, 42x60 in. *Collection: Mr. and Mrs. Thomas L. Parker, Wyoming*

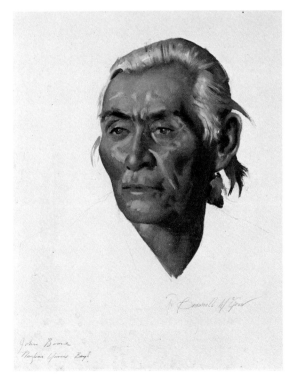

Plate 12. Field Study, NESKAI YAZZIE BEYIH, *oil, 18x14 in.*

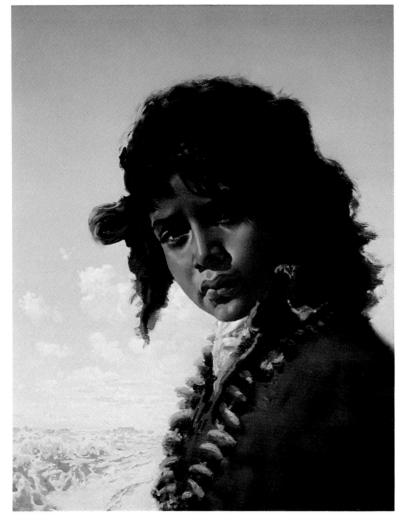

Plate 13. YOUNG DIGNITY, *oil, 20x16 in.*
Private Collection: Lakewood, Colorado

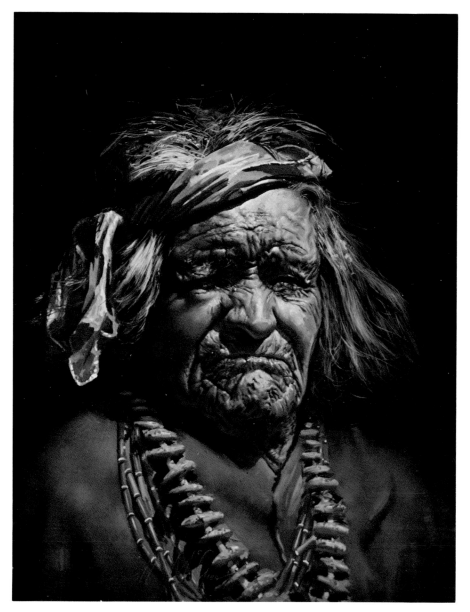

Plate 14. PAH-NIM-TEWA, HOPI POWAMU CHIEF, *oil, 20x16 in.*
Collection: Dr. and Mrs. George Walker, San Diego, California

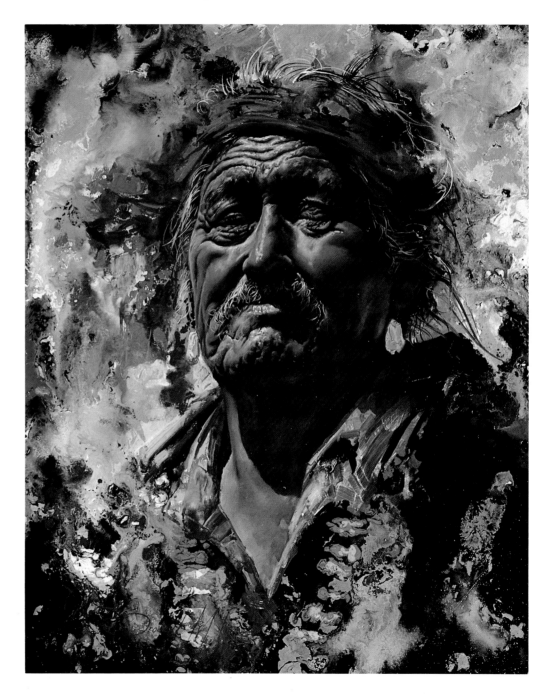

Plate 15. CHA-T'-CLUIE, *oil, 20x16 in.*
Collection: Mr. and Mrs. Mickey McArthur,
South Laguna, California

27

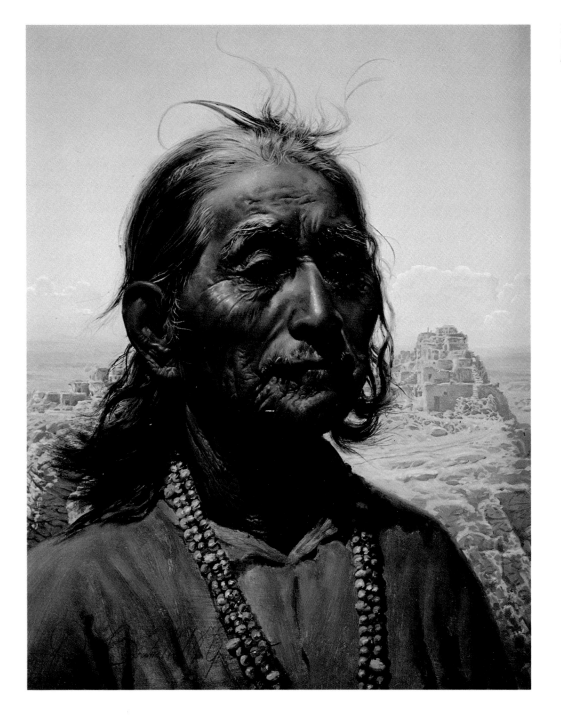

Plate 16. MESA CHIEFTAIN, oil, 20x16 in.
Collection: Mr. and Mrs. Mickey McArthur,
South Laguna, California

Plate 17. SUMMER HERDING, oil, 36x48 in.
Collection: Mr. and Mrs. Mickey McArthur,
South Laguna, California

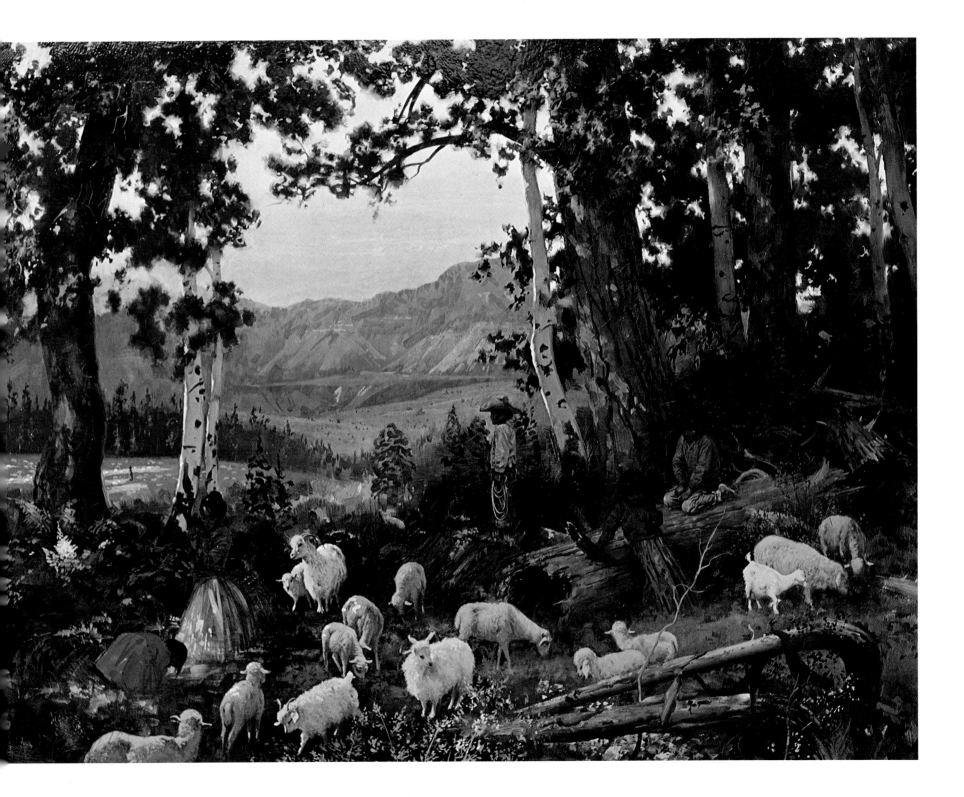

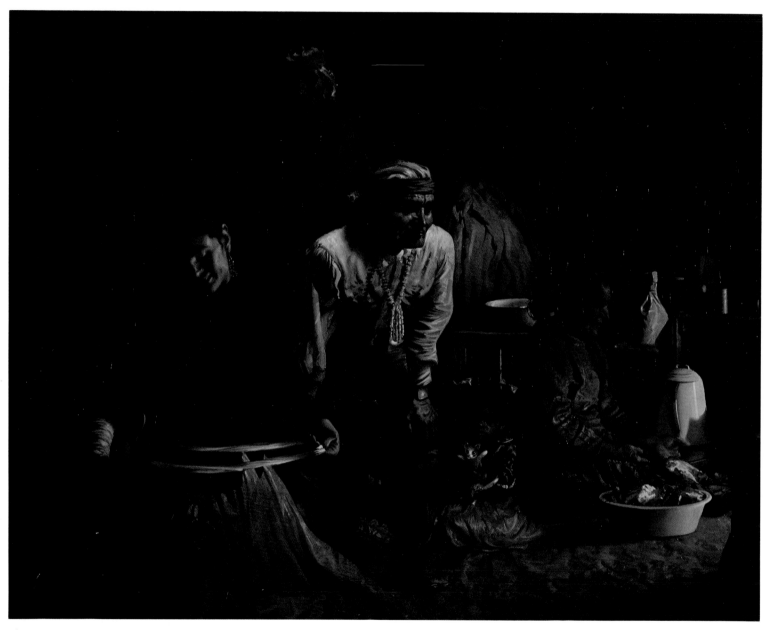

Plate 18. IN PERCY SHOOTINGLADY'S HOGAN, *oil, 35x45 in. Collection: Mr. and Mrs. Wilbur Koenig, Boulder, Colorado*

30

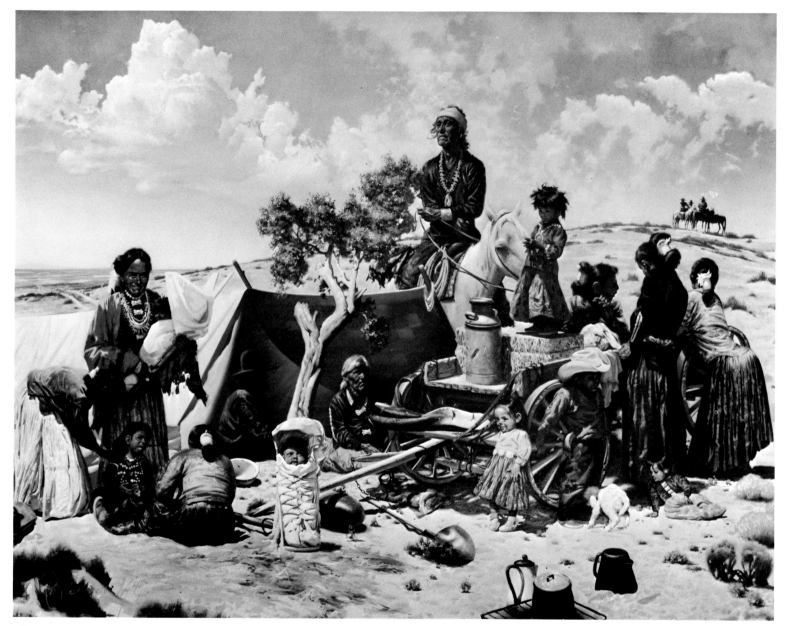

Plate 19. NAVAJO ENCAMPMENT, *oil, 36x48 in. Collection: Mr. and Mrs. Mickey McArthur, South Laguna, California*

31

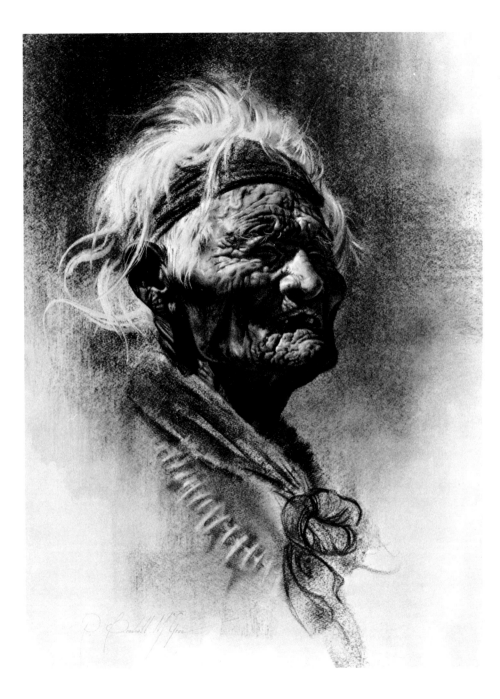

Plate 20. SI'-TCHAI, *charcoal, 24x19 in.*
Private Collection: Bozeman, Montana

32

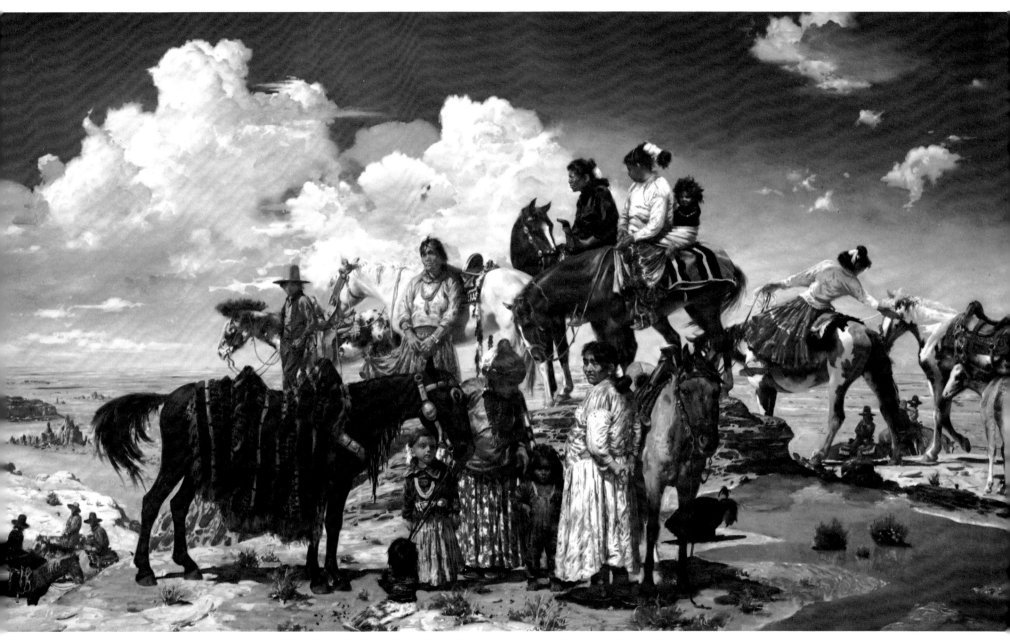

Plate 21. PAUSE ON THE WAY TO THE SING, *oil, 36x60 in. Collection: Mr. and Mrs. Carl S. Carlson, Ramsey, New Jersey*

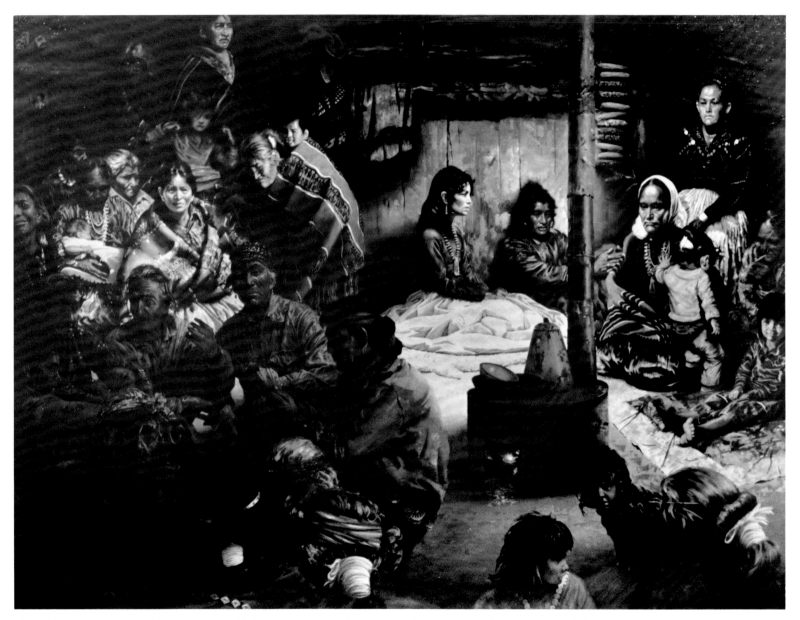

Plate 22. KIN-NAHL-DAH, EVENING, *oil, 45x60 in. Collection: Mr. and Mrs. Wilbur Koenig, Scottsdale, Arizona*

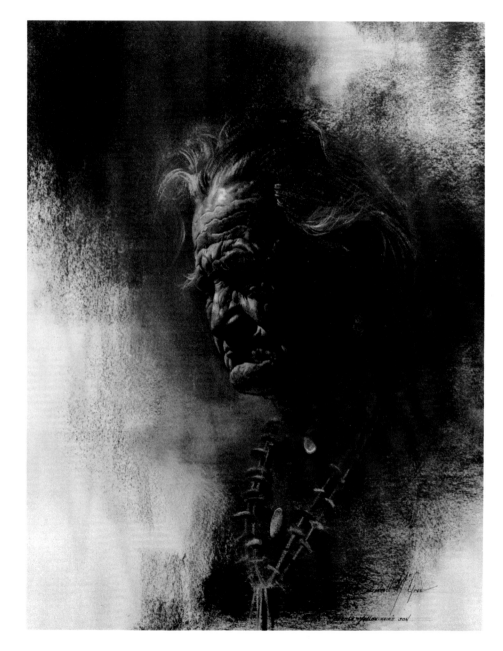

Plate 23. YELLOW HAIR'S SON (profile), *charcoal, 24x19 in.*
Private Collection: Phoenix, Arizona

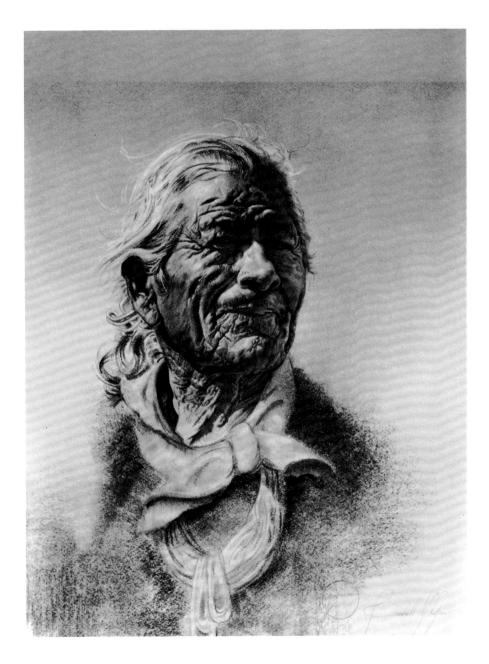

Plate 24. A NAVAJO OF THE KAIBITOH AREA,
charcoal, 24x19 in. Private Collection: Rolling Hills, California

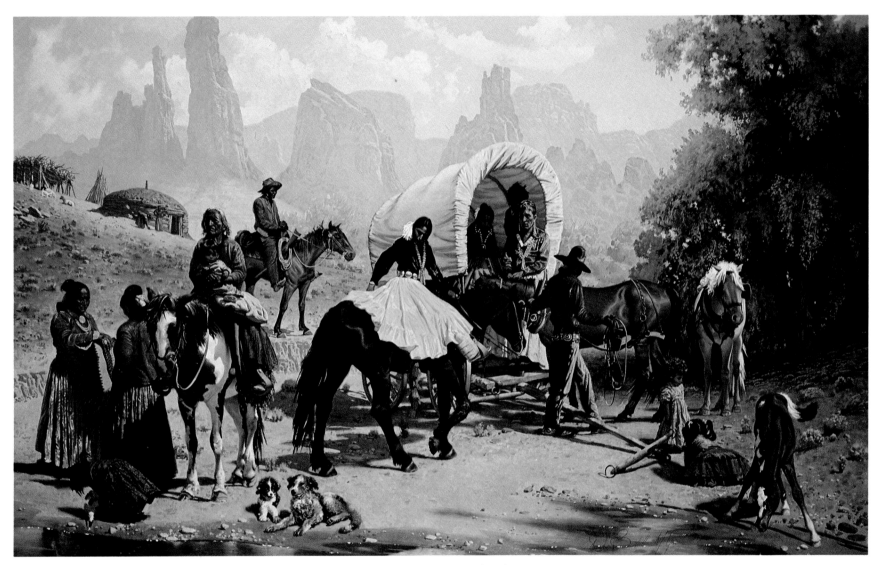

Plate 25. GOING ON A VISIT, oil, 41x66 in. Collection: Bryan and Steven Johns, Phoenix, Arizona

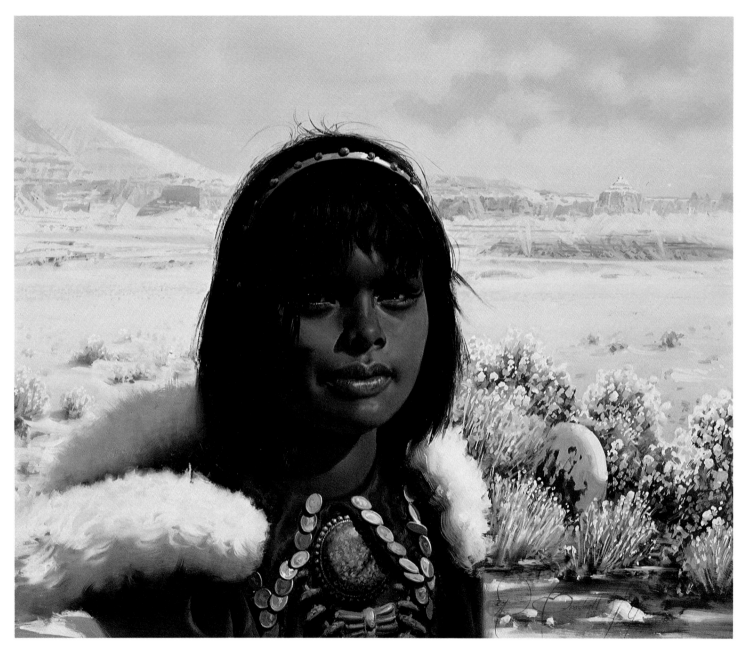

Plate 26. JEWELS OF WINTER, *oil, 18x24 in. Collection: Dr. and Mrs. Chester Z. Haverback, Rockville, Maryland*

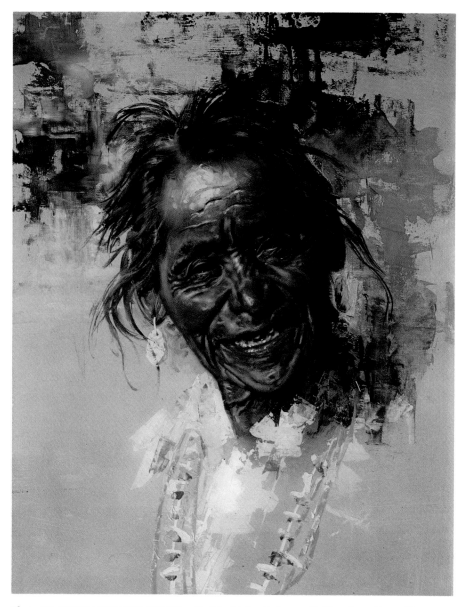

Plate 27. TSINAJINNI YAZZIE, *oil, 20x16 in. Private Collection: Post, Texas*

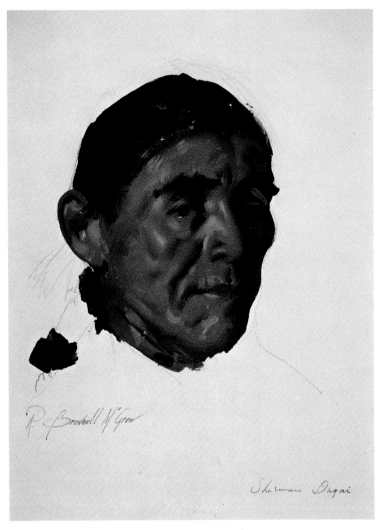

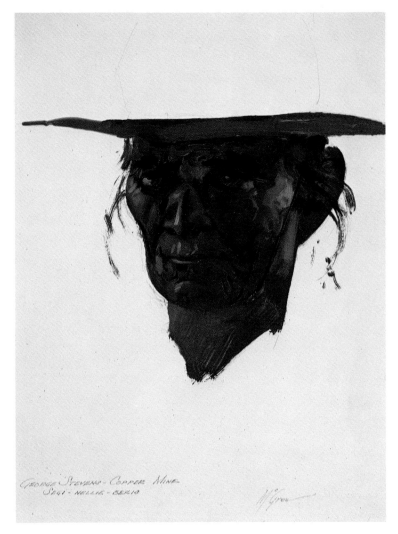

Plate 28. Field Study, SHERMAN DUGGAI, *oil, 20x16 in.*
Private Collection: Palm Springs, California

Plate 29. Field Study, TSEGI NELLIE BEKIS, *oil, 20x16 in.*
Private Collection: Palm Springs, California

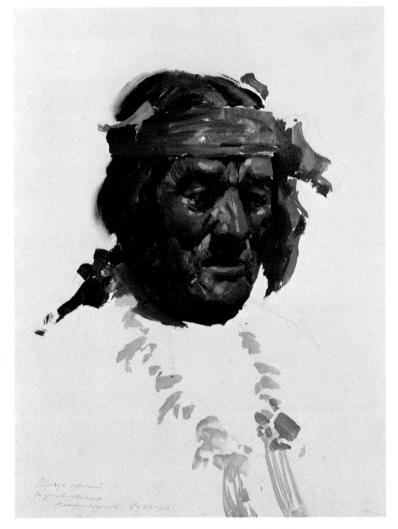

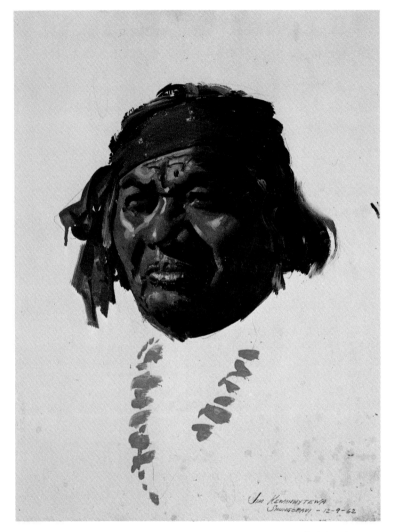

Plate 30. Field Study, KYUSHVEHMA, *oil, 20x16 in.*

Plate 31. Field Study, JIMMY KEWANWYTEWA, *oil, 20x16 in.*

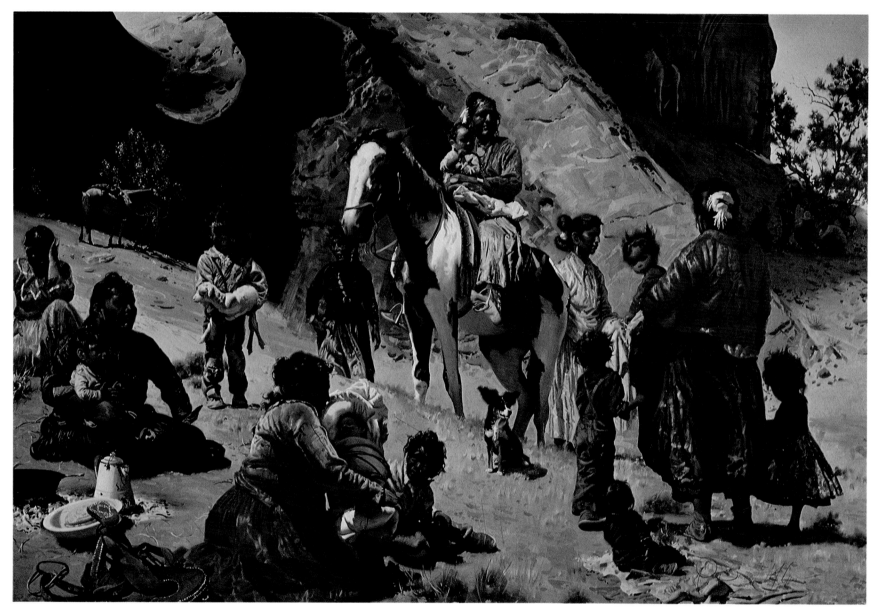

Plate 32. VISITORS, *oil, 40x60 in. Collection: Wallace Moir Co., Beverly Hills, California*

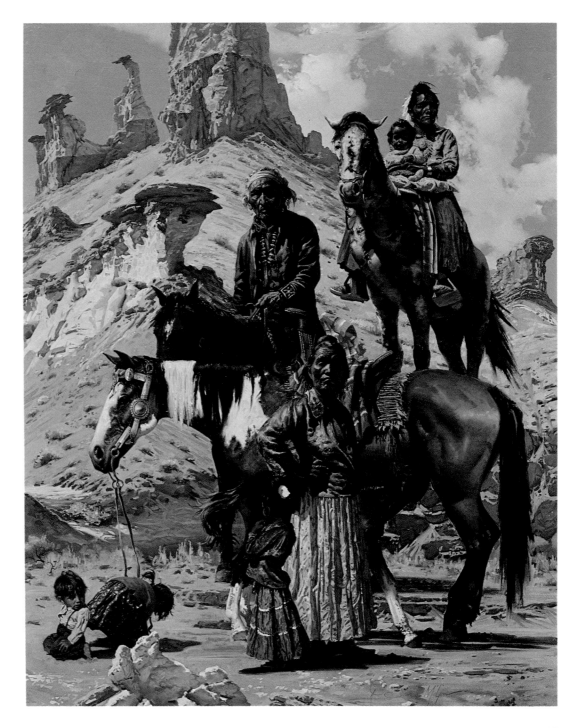

Plate 33. THE DINNEH, *oil, 60x48 in.*
Collection: *Mr. and Mrs. Mickey McArthur,*
South Laguna, California

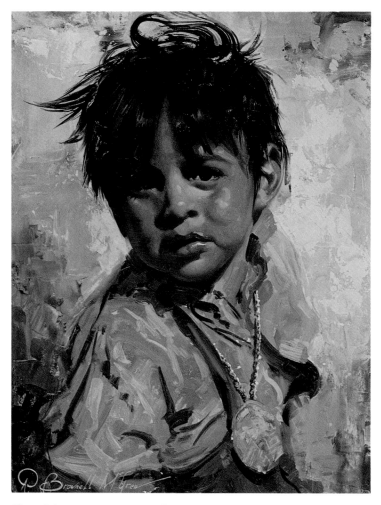

Plate 34. NAVAJO BOY, *oil, 20x16 in.*
Collection: Hon. Barry Goldwater, Phoenix, Arizona

Plate 35. BESSIE, THE HAPPY ONE, *oil, 20x16 in.*
Private Collection: Midland, Texas

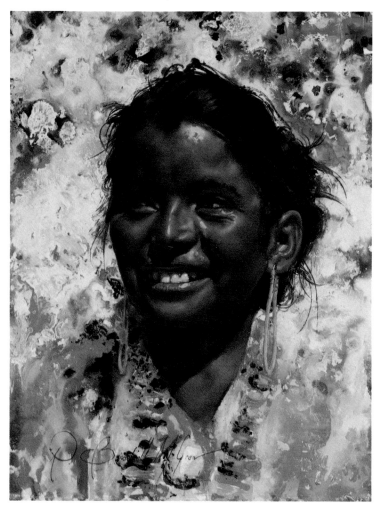

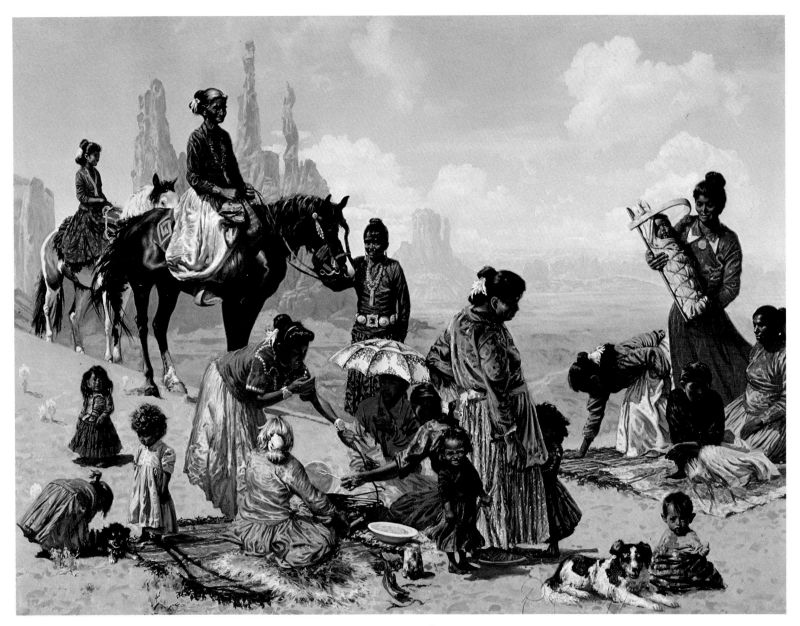

Plate 36. Variation on a Theme: No. 4 of 4, NAVAJOS AT MEALTIME, *oil, 30x40 in.*
Collection: Mr. and Mrs. Raymond Schlichting, Hillsboro, Kansas

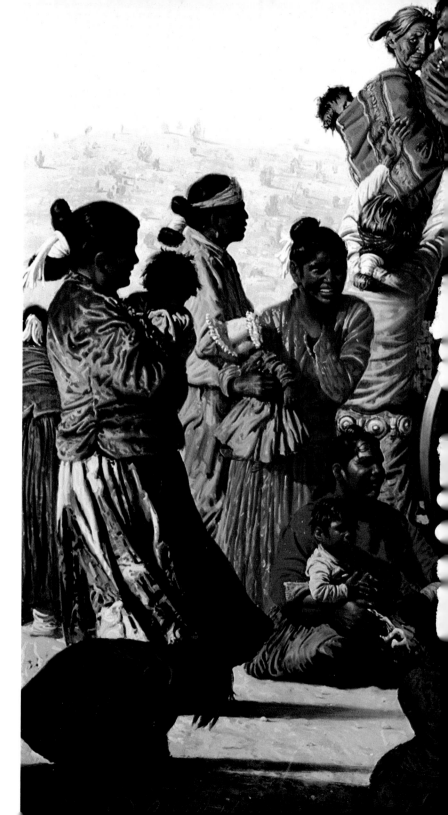

Plate 37. BESSIE BLESSES THE CHILDREN, oil, 34x60 in.
Collection: Mr. and Mrs. Herbert Ware, Jr., Midland, Texas

46

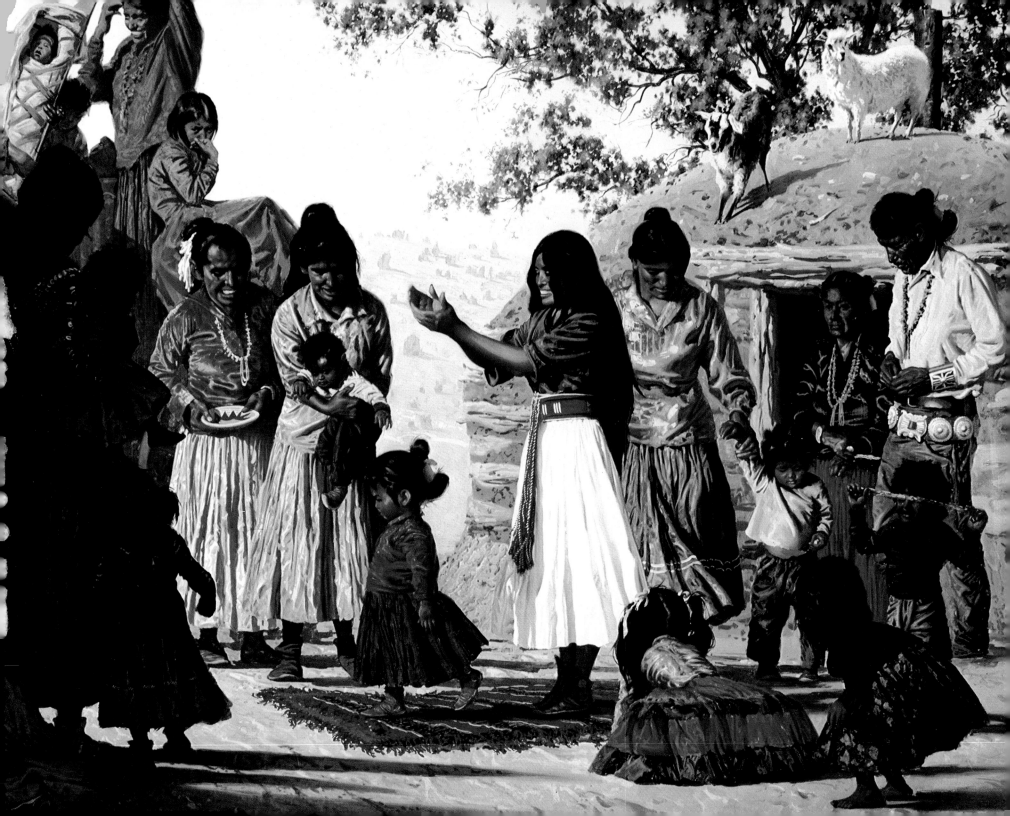

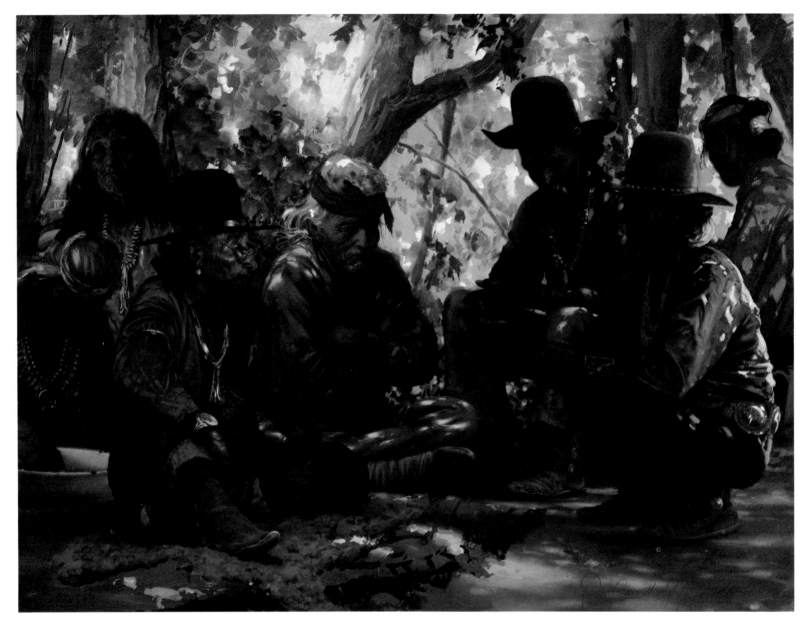

Plate 38. OLD ONES TALKING, *oil, 36x48 in. Private Collection: Lubbock, Texas*

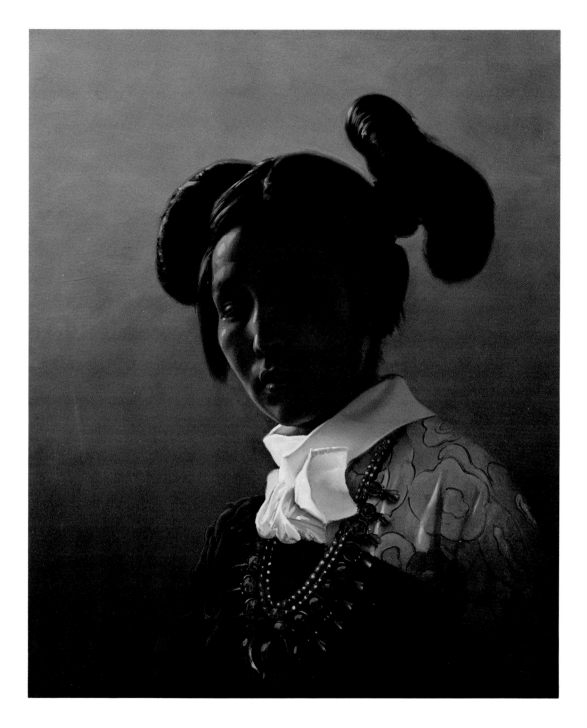

Plate 39. CO-CAG-HOW-NEUMA, *oil, 24x20 in.*
Collection: Mr. and Mrs. J. D. Ryan,
Phoenix, Arizona

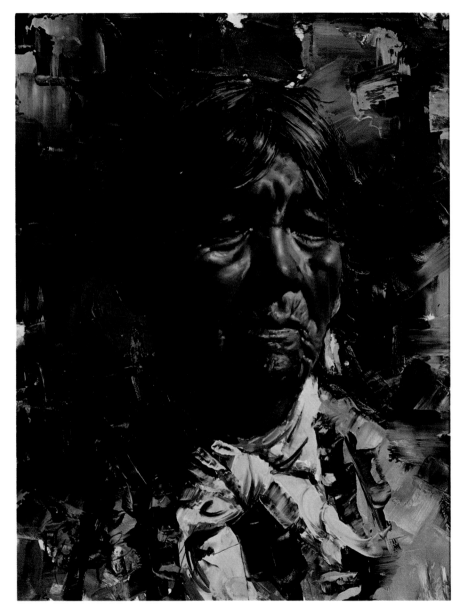

Plate 40. LINCOLN CHUHONGNONA, *oil, 18x14 in.*
Collection: Mr. and Mrs. Byron Hunter, Scottsdale, Arizona

Plate 41. NAVAJO PRINCESS, oil, 20x16 in.
Private Collection

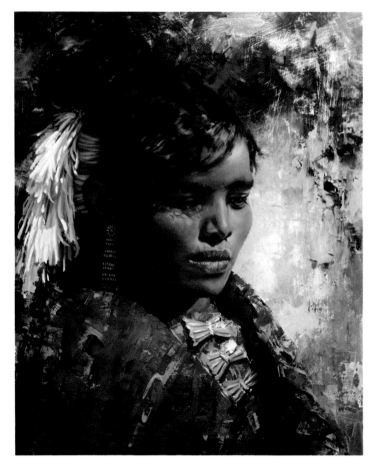

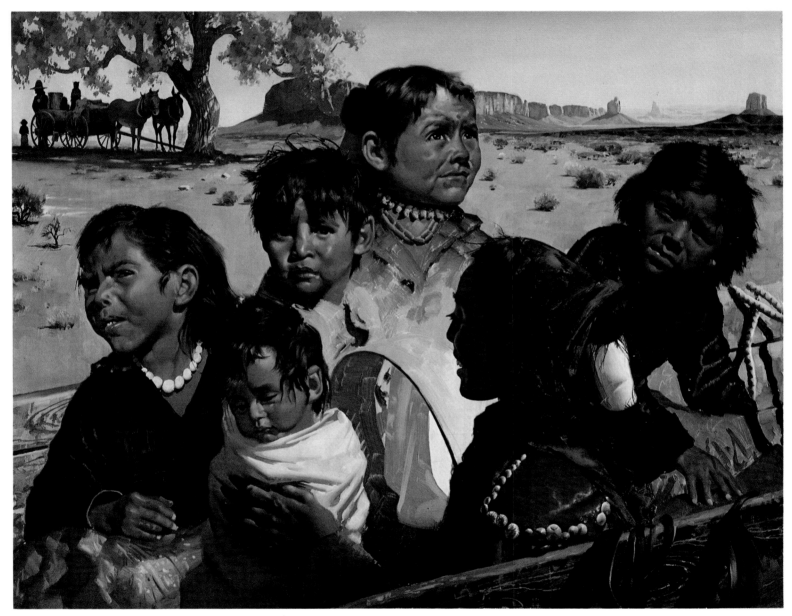

Plate 42. IN THE WAGON, *oil, 30x40 in. Collection: Mr. and Mrs. Gerald Conway, Cleveland Heights, Ohio*

51

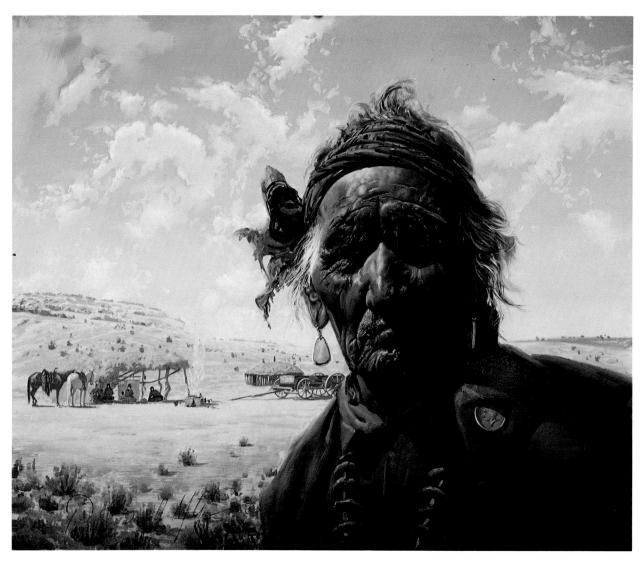

Plate 43. HASTI'-IN DUGGAI, *oil, 20x24 in.*
Collection: Dr. and Mrs. Robert J. Dellenback, Englewood, New Jersey

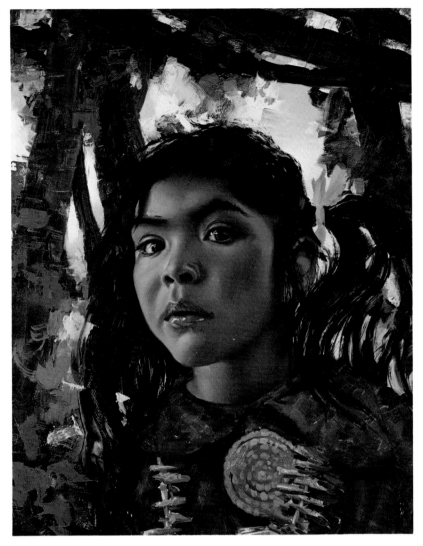

Plate 44. JULIA IN THE CHA-HA-OH, *oil, 20x16 in.*
Collection: Mr. and Mrs. Herbert E. Ware, Jr., Midland, Texas

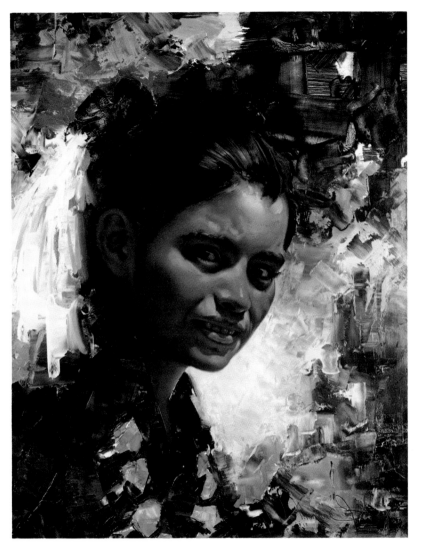

Plate 45. A FAVORITE, *oil, 20x16 in.*
Collection: Dr. and Mrs. R. J. Dellenback, Englewood, New Jersey

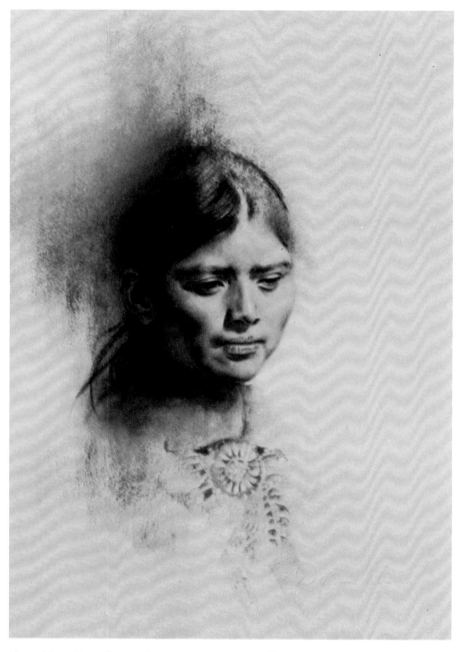

Plate 46. BESSIE, *charcoal, 25x19 in. Private Collection: Baltimore, Maryland*

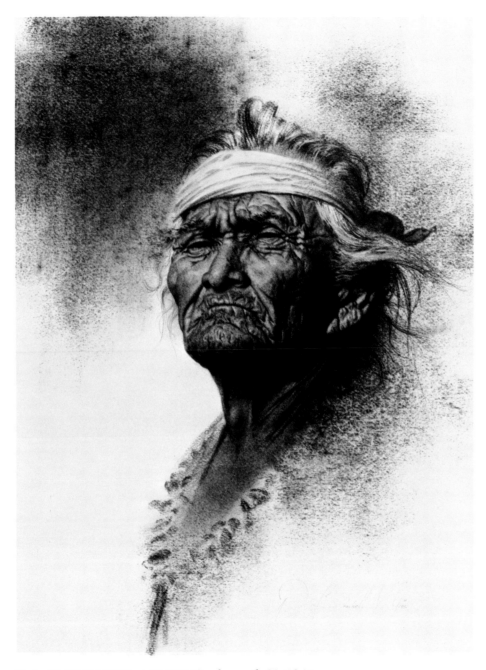

Plate 47. OLD JOHN, A NAVAJO, *charcoal, 25x19 in.*
Private Collection: Phoenix, Arizona

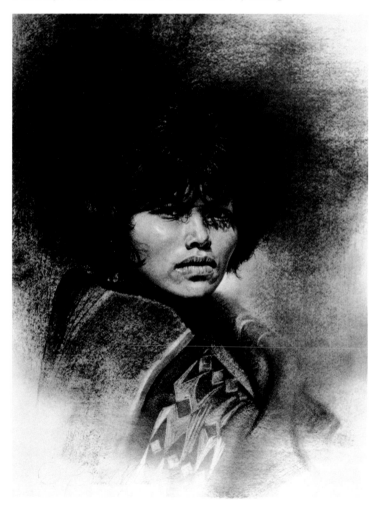

Plate 48. GIRL OF THE WINTRY LANDS, *charcoal, 24x19 in.*
Courtesy: Trailside Galleries, Jackson, Wyoming

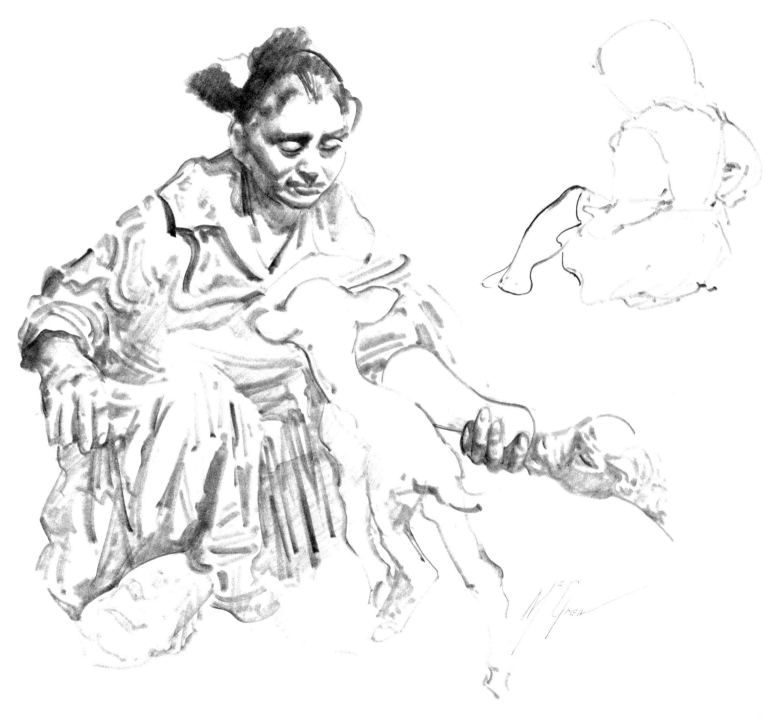

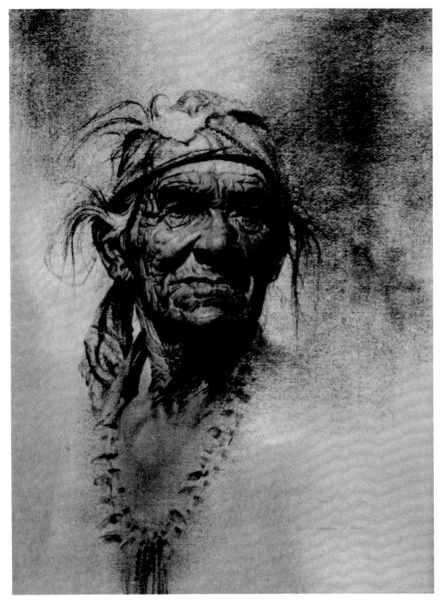

Plate 49. HASTI'-IN YAZZIE, *charcoal, 24x19 in.*
Private Collection: La Mesa, Texas

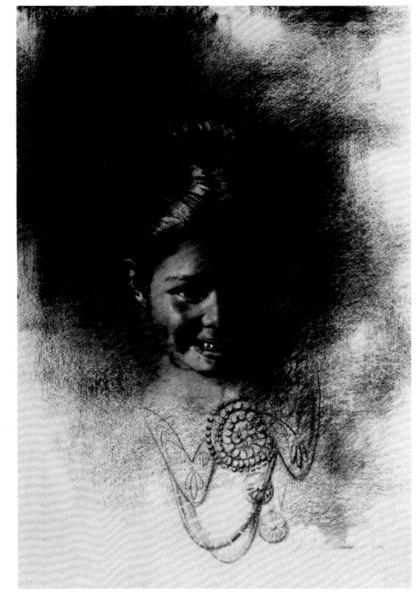

Plate 50. AHT-ED ZEE, *charcoal, 24x19 in.*
Private Collection: Phoenix, Arizona

58

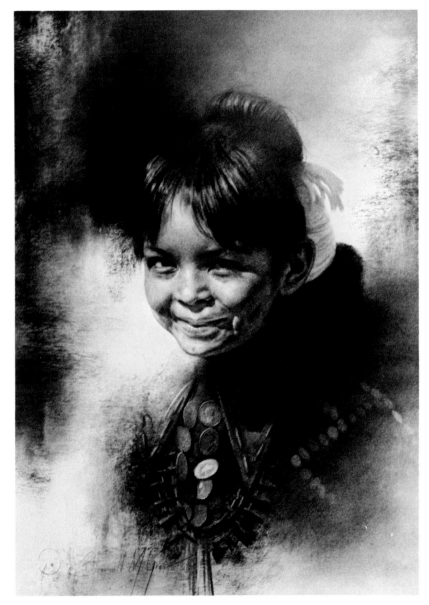

Plate 51. AHT-ED PETE, *charcoal, 24x19 in.*
Private Collection: Oklahoma

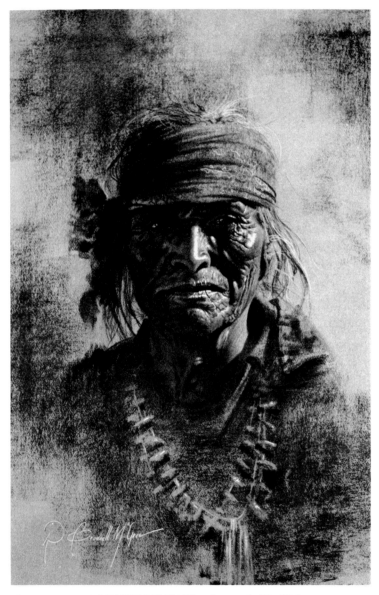

Plate 52. MAN OF THE NAVAJO, *charcoal, 24x19 in.*
Private Collection: Texas

people always want to know about the paintings

Offussatara Gets Gussied Up. Plate 8. The children and their mother here are a true family unit. As mentioned elsewhere, all of the Indians are live models but were not necessarily present together in the scenes depicted. In this painting, however, the artist has captured a moment of actual family life, as the mother prepares her daughter for participation in a ceremony.

The shawl worn by the Hopi mother is from Japan. These bright fringed silky shawls are now the favorite choice of Hopi women.

Offussatara's name, oddly enough, is not Hopi but was provided by an older sibling who was at an Indian boarding school during the time Offussatara was on the way, and he had two foreign classmates whose names he especially liked. One was from Japan, the other from India, and their names were Tara and Offussa, so what more natural than to suggest the combination to his mother?

Idyll. Plate 72. The use of hot and cold is seen in many McGrew paintings. Perhaps the best example is *Mesa Chieftain*, Plate 16, where Ned's incredible face is posed before stone dwellings in the background. Another example is found in *Summer Herding*, Plate 17, where cool pasture is contrasted with shimmering desert distances.

According to the Oxford English Dictionary, the creator of an idyll is an "idyller" (1895, *British Weekly*): "That life which lies just behind today, and would soon be quite forgotten if it were not for the 'idyller,' who has saved some of the best for us."

Saturday Morning. Plate 114. Jill was nine years old when this was done and was less than pleased to be immortalized on canvas in the midst of a hairwash. Lest you be concerned that the McGrew children do not always wear beatific expressions in their paintings, we can assume each was probably whisked away for posing from an all-consuming youthful activity.

Variations on a Theme. Plates 36 & 76. Two of four paintings done around the

general concept of Navajo cookery. Frybread, a staple of their diet, is made of flour, baking powder, salt, and water, beaten out between the hands and deep fried. Indian food is prepared differently from ours, and most Anglos find it takes a fair amount of gastronomical adjustment.

Tsayei. Plate 7. This is the Navajo name for Canyon de Chelly. It is another example of strong chiaroscuro, with the brilliant fall coloring of cottonwoods against the dark mountains.

Study of a Child's Head. Plate 106. This was undertaken as a discipline, to paint with the ultimate degree of realism.

Im Das Herzen's Frühlingskeit. Plate 91. "In the Springtime of My Heart." In April when there has been sufficient moisture the desert will be carpeted in evening primroses.

When Ironwoods Bloom. Plate 115. The sight is unbelievably lovely, especially for those who only know the desert in its sun-baked aspect. The blooming of ironwoods is a capricious thing and does not occur annually. "But who can paint like Nature? Can imagination boast amid its gay creation, hues like hers?"

The late Jimmy Swinnerton loved the ironwoods and referred to their bloom as "a dainty color."

Recently I heard an interviewer ask Marge Champion what to look for while viewing a particular dance ensemble. She said, "There are many concepts in technique, but I prefer to regard it as I would a beautiful painting and just let it wash over me."

Evening of Bessie's Girlhood. Plate 62. A quiet period shared by the girl and her parents during her maturity ceremony. This painting, *Kin-nahl-dah: Evening,* and *Bessie Blesses the Children,* all concern this very personal ceremony to which few beliganos are invited. McGrew's account of his experiences during one of these observances is found in another section of this book.

Bessie Blesses the Children. Plate 37. During the maturity ceremony the girl is believed to have special blessings to impart. These are molded into her body by the woman who serves as "pattern" and through her to the blankets and thence to the owners of the blankets as they receive them from the girl. All the children and adults present come to the girl for laying on of her hands.

Dolce Far Niente, Navajo Style. Plate 11. An Italian phrase, "Sweet doing-nothing." Here the people rest under the cha-ha-oh (summer shade) which is made of juniper boughs.

The Race. Plate 71. Often it is asked if parasols are truly used by Navajo women. They are indeed. The Navajos are a gregarious, happy people, fond of sports and of gambling. They are good laughers and enjoy humor, but Anglos must be aware of the Buckskin Curtain. This is an invisible enclosure which the Indian will draw about himself when a tactless remark causes him to withdraw inwardly.

The jewelry which is so beautifully pictured in many of these paintings is worn daily. It represents their wealth, number of animals, and so forth and is a method of establishing rank.

At a scene such as *The Race*, one would hear a great deal of happy talking in the Navajo language. During World War II, Navajos were used very effectively in the Signal Corps for transmitting classified information since their language in its original form includes no cognates and cannot be translated by means of the knowledge of any other language. There are also no similarities in inflection.

The Newcomer. Plate 87. A beautiful example of still life and textural skills. This painting is atypical of McGrew's work, however, most still life studies being done as part of the whole dimension of a painting—as in *Navajo Encampment*, Plate 19.

In *Tonalea*, Plate 67, the building in the background is an historic

old trading post. It was composed of two stories, the upper containing a room with a billiard table. There favored Indians were allowed to play. In time the table became worn, and eventually the felt was torn and patchy. The Indians nicknamed it "poor pasture."

One of McGrew's much-loved possessions is a slat from an Arbuckle coffee crate, taken from this post where partitions were built from these wooden boxes.

Just in front of the door shown in the old building, McGrew paused one day in the company of Shine Smith, beloved missionary to the Navajo, who pointed to the ground and said:

"On that very spot where you're standin', Zane Grey nicknamed me 'The Hard-Ridin' Parson.' "

Entahl: In the Cookshade. Plate 3. After the meal is eaten there will be a squaw dance. This was originally a celebration to welcome returning warriors. In times past the women were able to pick a partner who would become a mate; today it is simply a festive occasion.

Kin-Nahl-Dah: Evening. Plate 22. The young girl's attitude seems to separate her from the family gathered here. She is perhaps looking toward her maturity rites and into the future with a degree of awe.

Sketch of Fritzl Sleeping. Plate 104. This is the artist's oldest grandchild, Frederick Brownell Eifrig, asleep on the model stand on a hot summer day.

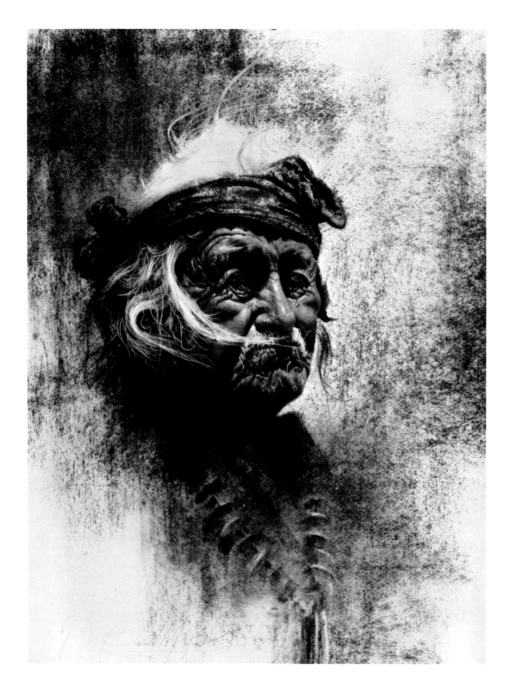

Plate 53. FURCAP, OLDER, *charcoal, 24x19 in.*
Private Collection: La Mesa, Texas

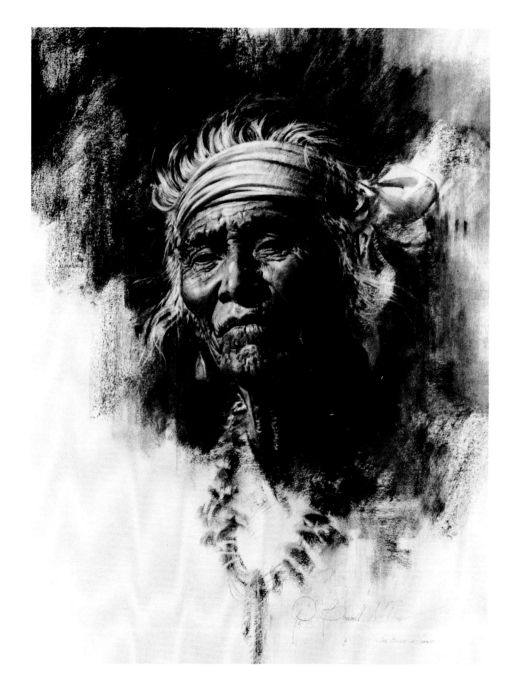

Plate 54. SAM BILLIE, *charcoal, 24x19 in.*
Collection: *National Cowboy Hall of Fame,*
Oklahoma City, Oklahoma

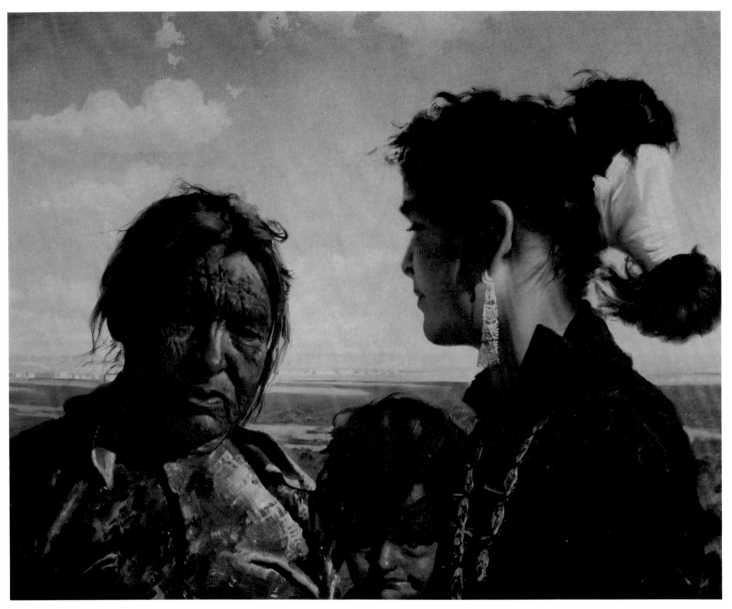

Plate 55. NAVAJO WOMEN AND CHILD, *oil, 24x30 in. Collection: Dr. and Mrs. George Walker, San Diego, California*

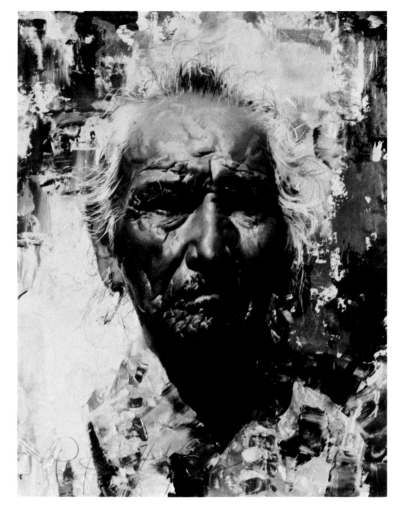

Plate 56. HASTI'-IN AUGUSTINE STORE, oil, 14x18 in.
Collection: Mr. and Mrs. Mickey McArthur,
South Laguna, California
Formerly in the collection of Read Mullan

Plate 57. HASTI'-IN TAH BADAHNII, oil, 20x16 in.
Courtesy: Kennedy Galleries, Inc., New York, New York

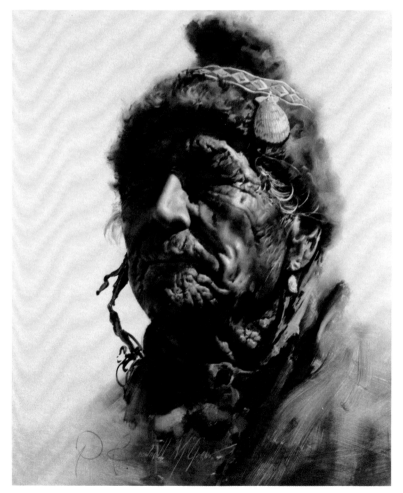

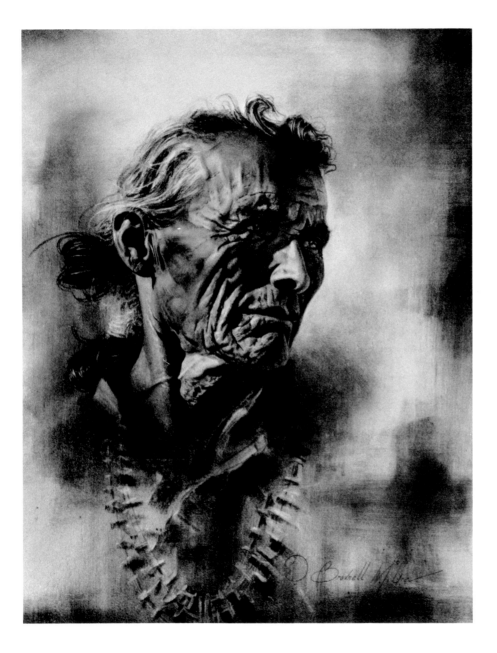

Plate 58. HASTI'-IN CHISCHILLIE, *charcoal, 24x19 in.*
Collection: *Mr. Fred Rosenstock, Denver, Colorado*

Plate 59. HIS NOSE IS STRAIGHT, LIKE A TALL PINE TREE, *charcoal, 24x19 in. Private Collection: Arizona*

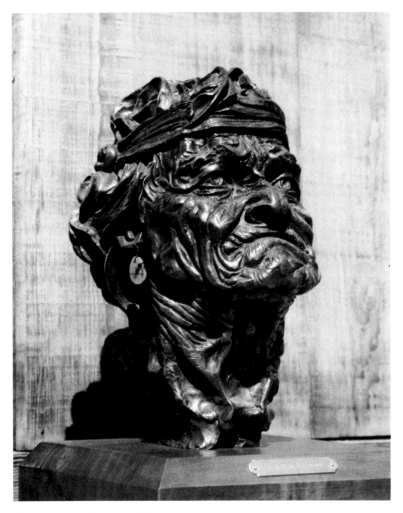

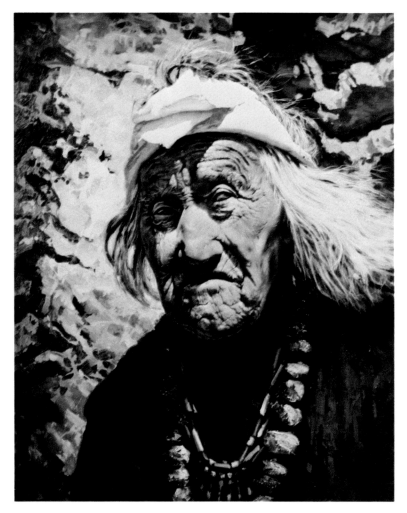

Plate 60. TSE GEDDIE, *bronze.*
Collection: Mr. and Mrs. Troy Murray, Scottsdale, Arizona

Plate 61. TAWA-QUAP-TEWA, HOPI CHIEFTAIN, *oil, 20x16 in.*
Collection: Valley National Bank, Phoenix, Arizona

...and what makes them so shiny?

McGrew calls himself a classico-impressionist, having been trained in the old school of intense discipline imposed before individuality is released. He produces very few paintings. Some are developed over a period of several years, brought along from original concept through multitudinous sketches, underpainting, and full working out of each dramatic passage.

Stylistically he is a complete individual.

Photography does not enter into the making of the final painting at any stage; the artist does, however, take many black and white photos of his subjects, and he does photograph paintings in process.

From the photographs of subjects, black and white sketches by the hundreds are derived. These sketches are done on 8 x 10 sheets and are all in the same general scale. From these sketches designs for the paintings are composed. Frederic Whitaker, N.A., writing in *American Artist*, said: "The practice of reconciling so many different points of interest in a single painting is a distinguishing mark of McGrew's larger paintings. His problem in combining so many key features into a harmonious whole must be similar to that of Rembrandt when he composed *Night Watch*."

The paintings are done on pressed-board primed with a white lacquer undercoat. Upon this surface a figure or a group of figures will be indicated in abstract form. Then other figures are added—still as abstractions. When the abstract pattern is completed (at this stage the painting looks like utter chaos to a layman) it is then converted to people, horses, trees, etc.

Over this the lay-in stage of painting is applied. McGrew's medium is linseed oil and turpentine—he is not one to experiment with materials and uses this time-honored medium exclusively. Sometimes intermediate stages are sealed with shellac.

When the painting has thoroughly dried, one heavy coat of damar varnish is applied. Honest Injun (no pun intended) that's all there is to the shiny-apple finish everyone always asks about. Joan Bucklew, writing in *Arizona Republic*, puts it succinctly:

"Most viewers are awestruck by the original paintings when they see the unbelievable combination of skill with an opulent jewel-brilliant gloss that is not apparent nor even hinted at in reproduction. There is no studio secret or magic trick to the jewel-glass surface. First McGrew paints with thinned oils and the painting comes out with a matte texture. Later he adds his gloss via varnish.

"The real visual magic of McGrew's paintings is his craftsmanship. The incredible finish is like an exquisitely polished blue-ribbon apple. That is, being a good polisher is relatively incidental to having something of excellence beneath the polish to show off. A less skillful painter would only accentuate all his flaws by applying such a varnish."

The people and the places in the paintings are real, though they may be separated by many miles or many years. Some figures of whom he is particularly fond appear in more than one painting, in the same way that a motion picture producer would use a favorite actor. Most notable among these is the little girl bending over examining something on the ground—someone has dubbed her "the bug picker." McGrew never learned her name, and just calls her his little bendy girl. She appeared first in *The Race*, Plate 71, and reappears with sufficient frequency to become something of a McGrew trademark.

Dr. Douglas Hale of Phoenix summed up in the *Arizona Republic* McGrew's technique with the comment: "Technically, one could call him baroque. Undoubtedly what will fascinate the viewer is the amazing resemblance to real life shown in the paintings. However . . . as in the baroque 17th century, the best paintings are those in which the artist has given us more than mere deft representation. In McGrew's paintings there is a use of shadow on the faces of the subjects which adds that something that catches the eye from across the room and makes one come back for a second look. One can call it 'mystery,' 'mood,' or 'poetry,' . . . but it makes all the difference."

how to paint an Indian portrait

John Wayne doesn't know it, of course, but he was indirectly responsible—very indirectly—for my getting one of the finest Navajo subjects ever to come my way, a magnificent old man named Red Burro, or Tchlellie Chee in his own tongue.

CBS was making a documentary, "John Ford's West," in Monument Valley, and the plan was to have all the Indians who had ever worked in Ford's pictures come and participate in a round of jollities. Friends in the Valley invited me to come on up for the doin's, as it was expected the area would be awash with superb old longhairs and so provide me with copious thrills. Ford, Wayne, Andy Devine, and assorted notables were to be on hand for the filming and to assure that ample attraction was offered the Navajos.

On my way north I stopped at a trading post and was astonished, mildly, to encounter a half dozen members of the Chief family, good friends of fifteen years' standing, and was pleased to have my attendance requested at Susie's Kin-nahl-dah later in the week. The family was trading fifty miles from their home area, not really an anomaly in Navajo life, and said they'd been trying to reach me by phone with no success, yet here we met far from our homes and with me intent on other matters.

After ascertaining what I could bring to keep the festivities festive, I promised to be there, tightened the cinch on my pickup and loped off to my interim destiny, which turned out to be the heady eminence of tour driver for Harry Goulding. The numerous crews of the film company were to be conveyed about and around to the various shooting locations by means of Harry's rigs, but one of the Dinneh engaged for the chore had found greener pastures or redder wine and failed to show. As I'd had extensive experience tearing cars to pieces in the hinterland, it was decreed that I should provide a liver treatment for a gaggle of unwary dudes, and I spent several pleasant days retaliating on Hollywood for a few of the excrescences they have used to pry me loose from hard-won pelf.

Then life got serious with the prospect of beauty, and I rolled swiftly and happily to a bleak distant canyon I had learned to love. A good dirt road wound up this arroyo for six or eight miles, then a wagon trail led off through a spur canyon and rimmed out eventually on a rolling mesa where Navajos were beginning to muster for the

celebration of Susie's maturity. The Kin-nahl-dah, or "Navajo cake," as they anglicize it, is to me the most lovely and attractive of the ceremonies of the People, displaying these wonderful folk at their winsome best. It is a relaxed and happy time, replete with incident, pervaded with gemütlichkeit, moving serenely through its age-old patterns to usher a fine Navajo lass into her new life.

Many years of friendship with the Chief family had made me warmly at home with them, and the relatives and friends now gathering to them seemed to sense this and accept my presence and picture-making activities as a proper element in the situation. Susie's mother, Dorcas, invariably greets me by taking my hand in both of hers, and then I know everything is as it should be. Jim, Susie's father, has five or six words of English while I have four or five of Navajo, which makes him teacher and me pupil, and we have sat for hours as he good-humoredly helps me increase my meager stock of lore.

The customary preparations were moving forward in leisurely fashion, and I was presented with successive tableaus that put me in orbit. Soon Lucy was doing Susie's hair, and if there is a lovelier sight than two beautiful Navajo girls so engaged, I look forward to seeing it. Much is made of the honoree's hair during the Kin-nahl-dah; it is specially cut with two short locks over the temple, and is worn long and unbound throughout all three days. Each morning and evening she leads all the children present on a run from the camp eastward, then back, and again a painter may well tingle at the sight of swiftly changing patterns in the long flowing tresses and flashing lights on traditional costumes.

Early on, however, a small cloud passed over the scene which presaged future trouble and eventual disaster. The two oldest Chief girls had married into families where booze was a serious problem; in one family they were bootlegging actively, and this son-in-law, Plowman by name, drifted into camp somewhat stupified but not yet in the belligerent stage. Things remained calm for the time, and soon Dorcas and I were on our way to the trading post for mutton and comestibles, their small flock not being up to providing for the vigorous appetites beginning to descend on the celebration en masse.

In the evening a grave contretemps developed when it was realized there were no corn husks on hand. These husks are very important, as they are used to weave a plaque that figures in the ceremony, and to line the firehole where the huge cornmeal cake is baked. When the family had deliberated sufficiently on this impasse, they asked me to take them to

one of the Hopi villages where I assumed they had acquaintances who could relieve their dilemma. It had been dark for a good while when we reached the pueblo, and I steered my crew-cab laden with bemused Navajos toward the center of the village, expecting to receive instructions on how to reach the home of the corn husk man. No such guidance was forthcoming, and my amusement and irritation burgeoned as I realized they hadn't the foggiest notion where to go or whom to see. We sat there in the dark while a muttering consultation went on fruitlessly, then I drove to the home of a Hopi I had known a long time and explained our predicament.

David had no corn husks himself, but he gave me directions to the home of Eva, who could probably accommodate us. Dorcas and I stumbled through the stygian streets and found ourselves at last in the home we sought, where Eva graciously received us and provided the necessary. While the transaction was under way I had time to examine the home, and found prominently displayed a photograph I had made of Eva's husband many years before. He had been badly in need of a new tire and consented to pose on condition of having his pickup reshod. Burbank used to get similar cooperation for an apple or an orange, but the old order changeth, and how.

This strange night received yet another bizarre touch as we proceeded homeward through the velvet dark of Navajoland. Several miles down the road appeared a glaring light, and as it came into view the kids exclaimed in chorus, "The fruit bus!" Soon we were rummaging through the wares displayed in this magic lantern, an old converted school bus that sat out there in the middle of the night and the center of nowhere, waiting for hungry Indians and spendthrift beliganos. In hundreds of thousands of miles traipsing the reservations, this was the only instance when I saw this contraption.

But sleepless nights and big outlays at the trading post are a tiny price to pay for the thrill awaiting me next day at lunchtime, when they called me into the hogan for roast ribs, and I, all unsuspecting, stepped into the presence of Red Burro. He crouched there in the ring of Navajos surrounding the food, an old man of shattering magnificence, plainly near the century mark, small, wiry, with the Navajo life and way evident in every detail and gesture. Despite his age he appeared to be out-eating any four of the rest of us, and I watched him fascinated, wondering how I came to be thus suddenly confronted with a superb Navajo from fifty or a hundred years ago, or three hundred.

As my spine convulsed the way it does when such a nonpareil comes into view, I felt I must not miss this one or lose him through some gaffe, especially precipitance, and I conceived that if I just took it easy and let him become accustomed to my picture taking, especially since dozens of others were now accepting it imperturbably, things would gradually ease into the proper mood and produce the requisite amenability in the patriarch.

So, notwithstanding my excitation, I made no move towards my quarry and contented myself with the routines of the day. We were running low on water, and the "pattern" had not yet arrived, so it was decided to combine these two errands. The "pattern" is a sort of matron-of-honor selected by the family to conduct the various portions of the Kin-nahl-dah, and to serve as a model for the girl involved, who then emerges from these observances with an essential likeness to the pattern.

We tied a number of barrels into the bed of my pickup and departed for a well near the pattern's home, where water was plentiful and easily available. Then we hied us to the pattern's camp, where things really began to come unglued. Billy K, husband of Susie's oldest sister and a grandson of Red Burro, was there, blind and fighting drunk, demanding a ride to the Kin-nahl-dah. Here were Scylla and Charybdis, and the lesser evil seemed to lie in acquiescence.

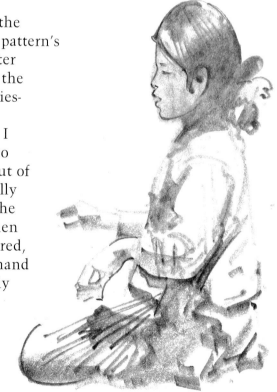

Back at camp, Billy fell out of the pickup and staggered off looking for trouble, while I helped three or four men unload the water. A donnybrook of some dimensions began to develop in the hogan and before long I observed Susie supporting her injured mother out of the camp to a safe distance. Then Billy and Rachel, his wife, were at it triple forte, and Billy stumbled from the hogan and lurched back in my direction, where I could only assume he intended to settle accounts with the white man. But he merely wanted to shake hands, then he wobbled away in search of someone else to mangle. And here a touching thing occurred, for after some minutes of additional hell-raising, he reappeared from the hogan, one hand tugged by his daughter, a diminutive bitsy perhaps five years old, but clearly the only person around with any influence over her besotted parent. She led him out of the camp to a pinyon several hundred yards off, where he sagged to the ground and oblivion. Old Jim watched this speculatively, and turned to me with a rueful grin.

"No good Nabba-ho," said he, the most English I have ever heard from him.

The water was unloaded, the chores were done, but all the fun was now gone out of

things for me. If there is anything that rouses my disgust and ire more than being around a drunk, it's being around a bunch of them. Without saying a word to anyone I climbed behind the wheel and lit out.

Red Burro was gone anyway, disappearing as silently and inexplicably as he had materialized earlier.

⊛ ⊛ ⊛

A few weeks later Susie wrote to thank me for my help at her Cake, but inquired somewhat plaintively why I hadn't stayed. My answer was designedly forthright, and shortly thereafter came a missive from Lucy, inviting me to a second Cake for Susie, and promising,

"This time there won't be any of those stupid drunk mens around."

As it turned out, there were plenty of those stupid drunk mens, but I went anyway, in no slight degree because of my eagerness to get Red Burro at any cost. This was the beginning of five years of disappointment and frustration, as one effort after another came to ashes. At the second Cake there was no Red Burro.

But there was much else, including a night of enchantment that has no equal in my memories of the People. The first day or two of the ceremony followed familiar lines, much picture taking and numerous easy conversations with various of the family and their friends. An exchange with Plowman stands out in retrospect because it adumbrated the tragedy that overtook him and Miriam. He had been telling me of a period he spent in Arkansas, and concluded cryptically that he didn't like it back there. When I inquired the reason for his disapprobation he said pensively,

"I drank too much."

Miriam came to me about the same time and asked if I could find her a summer job in the Verde Valley. She is one of the finest Navajos I've known and one I'd go a long way to help, but her query startled me because she has a steady job with the BIA in her home locale, which makes her one of the more fortunate. When I asked for an explanation, she replied moodily,

"Too many squaw dances up here in the summertime," by which of course she was simply echoing her husband. This reminds me, parenthetically, that an outstanding young Navajo friend told me recently he predicts the squaw dance

will be extinct in four or five years, demolished by firewater.

We made trips to the trading post as usual—more mutton, cowboy boots for two of the girls, various items for the proceedings at home or just garden variety usefulness. They decided after a time that what they really needed were a few live sheep for slaughter, and Dorcas knew a lady whose large flock would probably make her willing to part with some, so we spent hours wandering about on this quest.

Miriam had a new baby she wanted pictures of, and while we were thus occupied a bunch of riders charged into camp so drunk their horses staggered. It amused and gratified me to see the alacrity with which half a dozen people sprang up and rushed to handle this potential calamity, hustling the inebriates off their mounts and into a hogan where they spent a quarter hour or so expatiating on the dire consequences of such behavior. My curiosity prevailed and at length I sauntered down to the hogan and entered to see what might be going forward. The ringleader gazed blearily at me and growled,

"Whutchoo doon here, man?"

I said I was just taking pictures of the baby, and handed Miriam a dry Polaroid.

"Man, we doan want no tekin pichers of babies out here," came the next move in the game. I explained soothingly that I was merely acceding to a request, and left this notion to make its way through the alcoholic miasma. In a short while I crossed my fingers and left, hoping my friends would cope.

They did, and soon los borrachos were weaving in the saddle as they disappeared into the brush.

Now came mixing of the batter, a major part of the penultimate day's activity, taking nearly all afternoon. At twilight the cake was poured, the fire rebuilt on the hole, and everyone melted into the tenebrous surroundings and his private concerns, for nothing more would occur until the arrival of the medicine man, the hatahlie, who would chant the prayers throughout the night. A figure came toward me through the dusk, and proved to be Miriam with a request.

"My mudder say for you to tek us to find a medsin man."

A pretty pickle indeed, as someone put it. The central and concluding portions of the observance were upon us, and no arrangements had been made for that sine qua non, the

singer, whose ministrations provided the seal of authenticity for the entire affair. Before long Jim and I were on our way to a desolate area some miles to the northeast in search of Tall Salt, a highly respected singer they particularly wanted. He was an unusual Navajo in that he ran a trading post himself, which post we found, but no Tall Salt. The post was a dreary little shed whose few shelves may have supported a dozen items looking even more bedraggled in the wan illumination of our flashlights. Several boys were loafing about the place and explained that Tall Salt was far away conducting a sing; there was no chance he could officiate for Susie.

Miriam had accompanied us, and she and her father went into another consultation, the result being a decision to "take Sammy Shortfinger." Sammy was a minor league singer whom I knew slightly as a helper and interpreter some years previously, and a few miles of bouncing and slithering brought us to his camp, but to another frustration—no Sammy. As I reconstruct the situation in the light of subsequent events, it seems likely that Sammy was away on a philanthropic endeavor at the home of a friend, an old man of nearly eighty winters, who had taken unto himself a bride of twenty springs. Into Sammy's generous mind there crept an idea that he could be a friend indeed by helping this old fellow with his presumptively onerous connubial chores, and he proceeded to act on that assumption. This ménage-a-trois subsisted for quite some time, oddly enough, and odder still, did so in plain sight of all and sundry. One day as Sammy lounged in the hogan, recouping his forces, I suppose, the septuagenarian decided to show he was still capable of pulling a trigger, and blew away some portions of anatomy that Sammy found were indispensable to his continued existence. Exit Sammy Shortfinger.

We tried several more possibilities but met with like success, so it was decided we should return to camp where a plenary council could be called. This we did, after which Jim and I were fed supper by the light of a kerosene lamp. Our quiet repast was suddenly interrupted by shouts and bellows of the mounted revellers who returned to make the welkin shudder, giving me the idea that, mutatis mutandis, it was quite like a meal in a Scottsdale bar.

Not long afterward we were off again to another area where several medicine men lived widely scattered. We scattered the pickup just as widely, but to no avail, and the

night wore away as we churned through seas of sand and chaparral. The last place we tried, as I remember, was a strange little huddle of hogans and shacks that lay in an indented bluff a mile from the road, and had about them an aspect of forbidding, even threatening, gloom. Jim was oblivious of this, or was not going to let it interfere with doing the right thing for his lassie. I switched off the motor and the lights as he debarked and walked away into the night toward a hogan an eighth of a mile off. It must have been a full half hour that I sat there in eerie darkness, only an occasional muffled sound coming from some indistinct quarter of the compound. At long last two figures came glimmering like ectoplasm from the murk, but alas, one of the figures stumbled and staggered in familiar fashion and it was all too evident that the hatahlie's utmost exertions barely sufficed to keep him approximately erect. He and Jim drifted away into other shadows, leaving me to another ten or fifteen minutes of meditation and the speculation they were using the time to find the singer's fetishes and paraphernalia; also, I hoped, to imbibe a gallon or two of hot coffee.

But at last Jim came despondently back to the car and signalled that we were to head home. It was now after midnight and every expedient he could think of had been tried with failure complete. Back we went, and I assumed they would simply dispense with this portion of the proceedings, perhaps out of sympathy with the remark of an Apache acquaintance of mine as he commented on a ritual, "It's just a superstition anyway." I didn't know my man.

During the latter part of our meanderings, a full moon had risen to cast an ethereal veil of silver over the stark desert, so I positioned my pickup athwart her beams and spread my bedroll in the shadow created alongside. In seven seconds flat I relinquished all consciousness of medicine men, moonlight, roast ribs and Red Burro.

Whether the Queen of the Night waked me with her refulgent glories I do not know, but some time in those still small hours I started wide awake, conscious at once of the supernal loveliness of the dreaming moonlit earth and the soft chanting that whispered into the night from a hogan on the edge of camp, together with a faint broken glow from chinks in the structure. Hurriedly

resuming what clothing I had put off to sleep, I went eagerly down the slope and entered the hogan, expecting to find it crowded with several dozen Navajos gathered for the culmination of the observance. What met my eyes was far more arresting than my expectation.

Opposite the door sat Jim and Silas, chanting the prayers for Susie through the long stilly hours, sometimes singing together, sometimes alternating solo. Before them burned two kerosene lamps, the only light. Four other people completed the group, Dorcas and one other older woman, and a girl about Susie's age. The lamps cast a soft shadow from Jim's body onto the hogan wall beside him, and in this penumbra Susie was seated, her exquisite face glowing with tranquil happiness. Time seemed to halt in these magic hours as the songs succeeded each other in bewildering amplitude, but the smile never left Susie's face, only changed a bit now and then as the prayers stressed different aspects of her beatitude. She sat not quite touching her father and it seemed as if the same thoughts were lodged in her mind and in mine—how wonderful and good it was to have her unwell father singing prayers for her hour after hour while others were wrapped in the sleep he could well have used himself. It was impossible not to contrast this picture with others more familiar, to wonder how many white fathers are yet capable of such affection and concern when it has become so easy and common to have recourse to the surrogate of checkbook love. So long as I remember anything, I expect the quiet scene in this rough, primitive hut to be etched in mind and heart for almost unexampled beauty and poignance.

One other element in this ritual piqued my interest profoundly. Jim had a pouch of sacred pollen called tada-deen, and he occasionally took this between thumb and forefinger, then touched it to his head and breast in a gesture strikingly reminiscent of the Christian crossing himself. The others followed suit, and for the thousandth time I wondered how far we may justifiably hope to extend the application of Our Lord Christ's enigmatic saying, "Other sheep I have which are not of this fold." Misericordias Domini.

At last night's candles were burnt out and jocund day stood tip-toe on the misty mountain tops (not mine, one of Jeeves') and the camp began to stir drowsily. The cake was unearthed and distributed, the pattern gave Susie's hair final attentions and prepared her to transfer blessings to the assembly, and people began to get ready for departure. Incidentally, the cake was a good one—it is bad luck to have it charred or spoiled. I rid myself of excess lucre to numerous individuals who had been generously helpful as I went about my work throughout

the several days, then was soon on my way.

No I wasn't, either, as something jogs my stuttering recollection and I remember there were a couple of sick babies whose mothers desired them to be checked out at a hospital fifty miles off. Another half day was consumed in this operation, and we returned to camp to find Susie cheerfully undergoing her traditional extra twenty-four hours of wakefulness to demonstrate her fitness for the new condition of womanhood. It was all a peak experience in the long saga of my search for Red Burro, tinged with faint disappointment at not finding him, but promising also the hope for future success.

⊛　⊛　⊛

Months glided into the past and became years in which sporadic efforts to catch the old man were foiled repeatedly. Various members of both families had been promised rewards in the form of money, boots, or whatever they desired, if only they were somehow successful in getting the old one in front of my Hasselblad, however briefly. A sketch of this will-of-the-wisp was ludicrously beyond question, and you take what you can get, in my experience.

One summer things seemed to be shaping up in propitious fashion and I decided to have another go and to persuade and hire some of the Chief family to guide me on an all-out expedition into the wilderness where Red Burro lived in his elusive manner of hopping about between the homes of his families and friends. A young relative of the Chiefs had returned from Viet Nam with a silver plate in his skull and a naturally surly disposition aggravated to heavy drinking and violence, which forced them to move several miles from their home on the mesa to another, which it now became my initial task to find.

As I searched, I passed some half mile from a camp where people were busy with construction of some sort, but I was too distant for identification and continued on a little way to a home of the Chiefs' relatives.

In this camp, where I knew they had sometimes stayed, I began to inquire about Jim et al, and was soon aware of a figure running vigorously toward us from the other camp. It turned out to be Miriam, and I sensed some distress I couldn't grasp, but our talk remained casual until in the natural course of things I asked about Plowman. The poor dear broke down and confronted me with the only instance I've seen of an adult Navajo weeping. Just a few weeks before, she said, they had gone to a squaw dance at which Billy K. and a brother were present. Early one morning Plowman stood talking with a group beside a pickup or wagon, when Billy's brother came

stealthily behind him and drove a knife into his skull.

In the subsequent conversations and my fumbling efforts to console, one fact became unmistakable—any efforts to get Red Burro through the Chief family were utterly beyond the pale of possibility for a long time to come, if not permanently. The murderer was of course a grandson of Red Burro, and it was dubious if relations between the families could ever be repaired.

But more years passed and some contact was restored. In this period I seldom saw Rachel or Billy K., but I heard of the gradually healing wounds and was enabled to keep some track of their grandfather. At last a day came when Billy's daughter wrote to ask some help which I was able to give (courtesy of the inimitable Danny Davey), and the door opened a crack. You may be sure my foot was in it promptly, and soon things were in train.

One fine day Jim and I climbed above my faithful wheels and set out for a cornfield which Red Burro and his family maintained some hundred miles off by highway, plus an additional ten by ruts.

Midway of our journey we stopped for lunch at a cafe, where I ordered a steak and urged Jim to do likewise. But he declined, ordering instead an array of coffee and soft drinks he kept sipping at while I destroyed the beef. As the last of the meat disappeared, Jim summoned the Navajo waitress and placed an order for lunch. A bucket of chili was soon before him, over which he broke several bales of crackers and proceeded to ingest the saltines while leaving the chili untouched. In self defense I ordered pie to keep occupied, and eventually Jim ordered pie when they ran out of crackers, also more coffee and pop to keep it all settled. It still is not clear to me who won the contest—his family told me later that he had ordered steak and couldn't eat chili. So much for Escoffier.

Before we got to Red Burro's cornfield our lunch received a battering no blender could duplicate as we traversed several miles of caliche which had dried like a giant waffle iron. We did reach the field, however, and found a dozen or so of the family enjoying the bright, warm day, sans Red Burro, who had gone visiting shortly before our arrival.

We stayed an hour mulling things over, getting directions to the camps where they thought our man might be found on the morrow. Then we eased our way back to the highway and pounded the pavement another hundred miles to camp. Red Burro had taken a deer trail or equivalent in the same direction but short and direct in contrast to our circuitous

hardroad, so that when we launched tomorrow's effort it would be across country in the outback to intersect his line of travel. We agreed on a plan of starting off at a good hour next day, and I left Jim at his home with my hopes high.

The day of the big game dawned bright and clear, but when I reached the camp it seemed that all was again in ruins. Jim was off with the sheep and everybody had scattered except Lucy who had been put in charge of assorted babies. She assured me, however, that I was not left in the lurch, but that they had decided to have Dorcas accompany me on this mission—why, I never discovered.

For the umpteenth time I headed off in quest of the si-tchai, this time in company of Dorcas, from whom I have never heard a word of English in fifteen years. But even I can follow a pointing finger and Dorcas's digit got a heavy workout as we launched ourselves into the tangled skein of ruts and wagon roads that form a patternless puzzle over the back country.

We began at length to stop at a few hogans where he might be by some happy accident, and some at which we stopped merely to ask questions. We even found several people who had seen the old man, but always he seemed several jumps ahead of us. Presumably Jim had relayed Billy's instructions to Dorcas and given her some idea of the camps to be sought, yet it appeared less and less likely, as the rough jolting miles and slow hours ticked off, that our scanty instructions were at all equal to the demands being put upon them. An occasional Indian we encountered would provide a lead, we would cruise to and fro, hither and yon, till I began to think it must have been a mirage I saw so long ago at Susie's first Cake.

The early hours of the afternoon were upon us when we descried some distance to the south a home of several buildings that beckoned us thither for another try. Arrived there, we found several young people, one a stocky vigorous buck who had excellent English which he used to inquire suspiciously what we were about.

"Yeah, he was just here. He's my grandfather. What do you want him for?"

This spooked me a little, as I'd come to regard any grandson of Red Burro's as a dubious quantity, but this one didn't seem to be the knife-wielding sort, and we fell into a brief discussion of his work as a silversmith. Unfortunately he had none of his products to sell, but he gave us a new set of directions on how to find his progenitor. He pointed to a small butte some five miles off, and showed us a notch or saddle in it through which a trail led to a home the old one intended to visit. Again we were on our way through sand and gullies,

over slick rock and under gnarled trees that snatched at anything coming to near. The miles fell behind us and as they did an unaccustomed depression settled on me, with a growing conviction that our long tedious trek was fey and useless. It was the middle of the afternoon, we had brought no food and were now following a road we had traversed early in the morning, presently leading us back to the trading post from which we had started. Nor did it seem to be taking us anywhere near the butte pointed out by the young Navajo, while my companion sat in non-committal silence, seeming to accept the defeat I had resigned myself to.

Suddenly she pointed to a track leading north, down which I could see a small cluster of hogans and shanties. Wearily I yanked the wheel over and headed for this camp where I came to a stop beside a stone building which seemed to offer more possibility of being tenanted than did the other somnolent parts of the place. For a few minutes we sat in silence, but at last a middle-aged squaw peered at us from the doorway and came slowly and reluctantly in our direction. Dorcas hung her head and remained mute, and as she showed no disposition to start proceedings of any nature, I despairingly jumped in and began inquiries, only to discover that our unwilling hostess had less English than I have Navajo.

Again it seemed all up with the good guys, but at this nadir the door of the house banged and two girls came like rays of sunshine into the forlorn picture. One of them was a bouncy gladsome lass of six-

teen or so, whose good English was more welcome than spring showers in our situation between a balk and a breakdown.

Our problem was quickly laid before her and sympathetic comprehension flashed across her friendly countenance. She turned slightly and raised her arm to point towards a hogan some hundred yards away on the north side of the camp. A surge of joy tightened my chest as my eyes followed the directing finger and beheld a figure reclining in the afternoon shadow of the hogan. There he lay, Red Burro in the flesh, one slender leg propped over the bent knee of the other, far from the madding throng indeed. The faded corduroys and the worn dusty moccasins could belong to no other. My long hunt was over.

R. Brownell McGrew

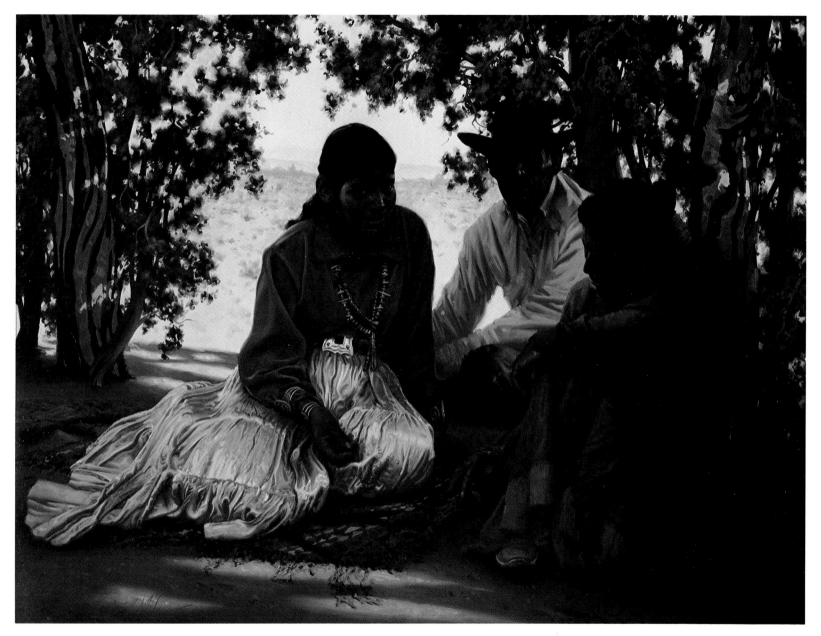

Plate 62. EVENING OF BESSIE'S GIRLHOOD, *oil, 30x40 in. Private Collection: Palm Springs, California*

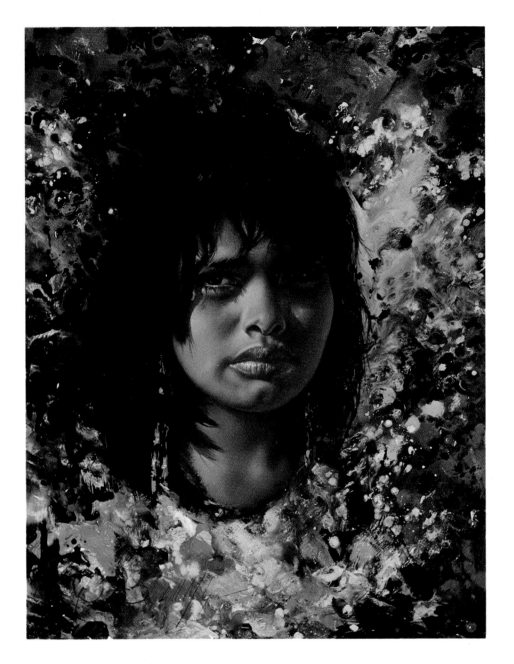

Plate 63. SHY LASS, oil, 18x14 in.
Collection: Mr. and Mrs. Mickey McArthur,
South Laguna, California

88

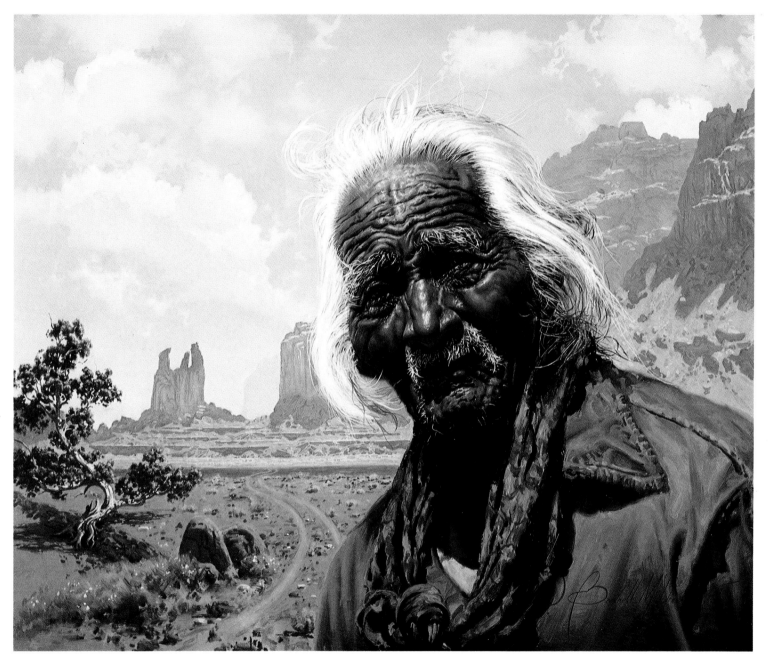

Plate 64. TCHLELLIE CHEE (Red Burro), *oil, 20x24 in. Collection: Mr. and Mrs. L. R. French, Jr., Midland, Texas*

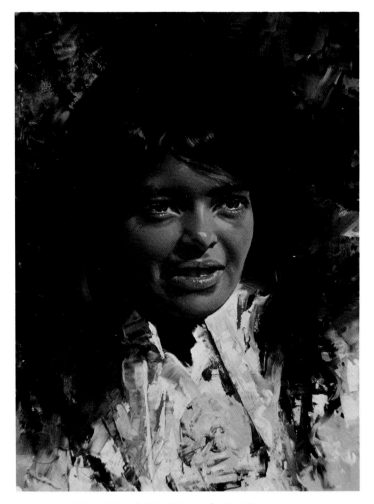

Plate 65. THE HOLTSOIE GIRL, *oil, 20x16 in.*
Private Collection: Kansas City, Missouri

Plate 66. WOMAN OF THE PLAINS, *oil, 24x20 in.*
Collection: Mr. and Mrs. William Riffle, Inyokern, California

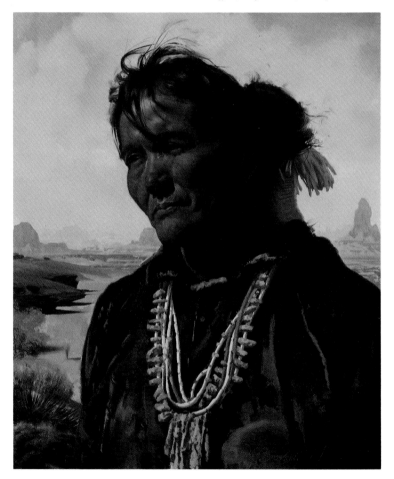

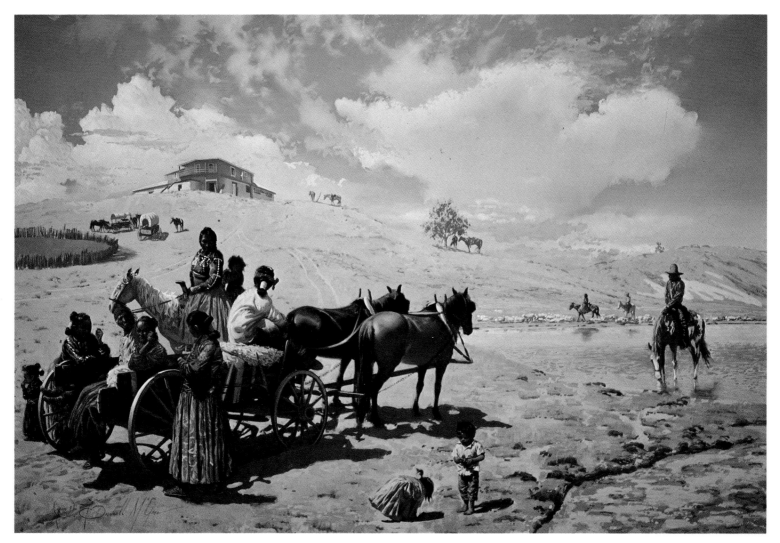

Plate 67. TONALEA, oil, 36x48 in. Collection: Babbitt Trading Co., Flagstaff, Arizona

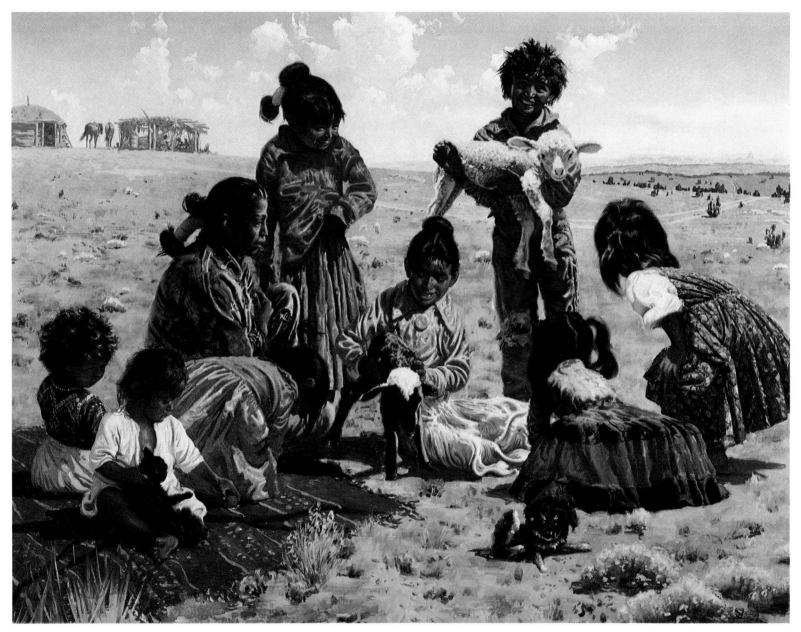

Plate 68. IN THE SPRING, *oil, 30x40 in. Private Collection: Lakewood, Colorado*

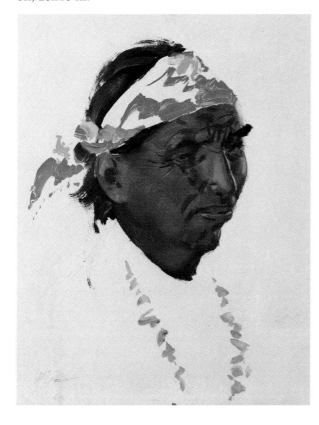

Plate 69. Field Study, MAN FROM MOENAVI, *oil, 20x16 in.*

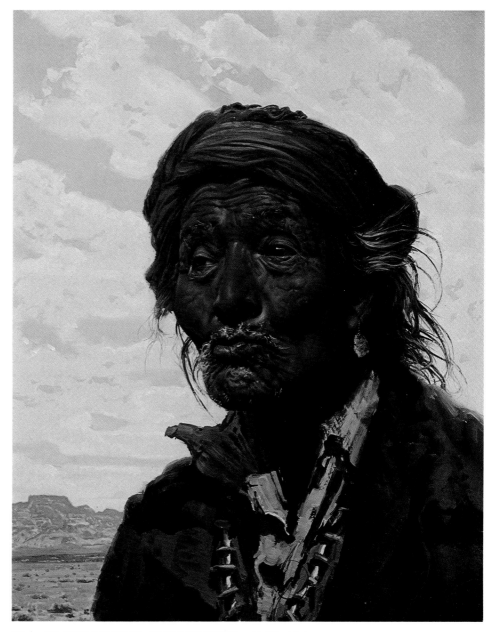

Plate 70. THE NAVAJO, SLEEP IN JESUS, *oil, 20x16 in.*
Collection: Mr. and Mrs. Ken G. Martin, Louisiana

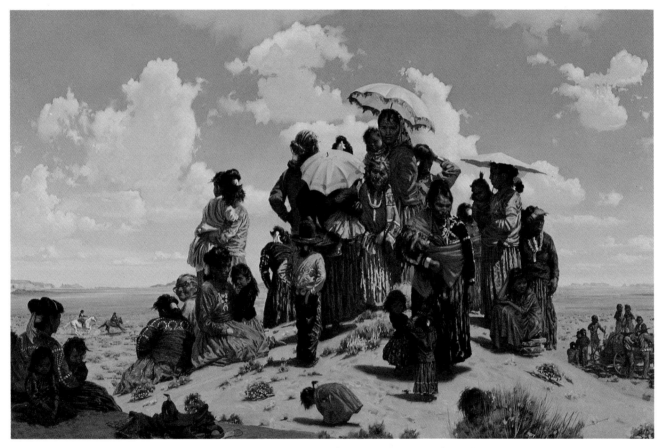

Plate 71. THE RACE, *oil, 30x48 in. Collection: Mr. Donald MacGregor, Sun City, Arizona*

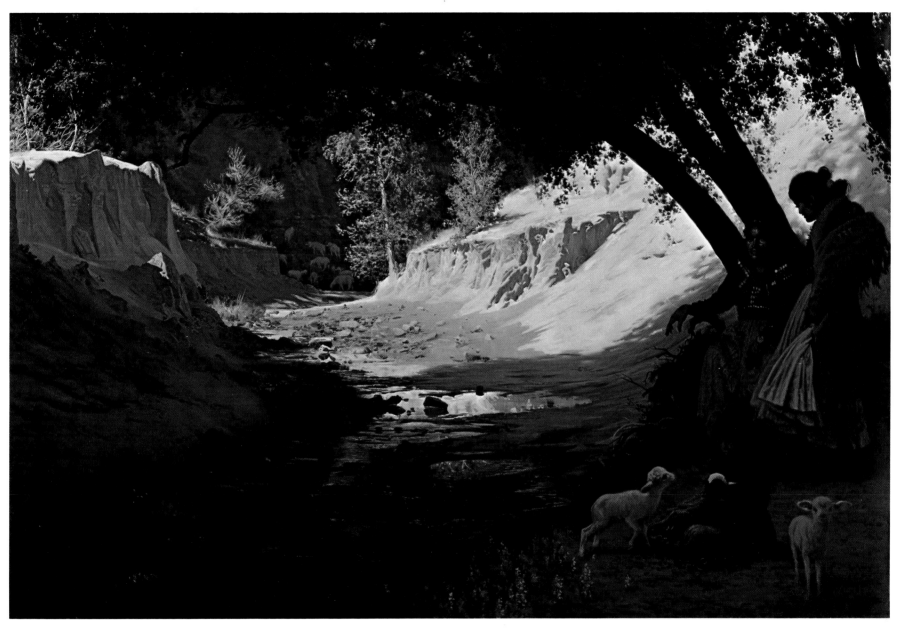

Plate 72. IDYLL, oil, 40x60 in. Collection: Mr. and Mrs. Henry Topf, Phoenix, Arizona

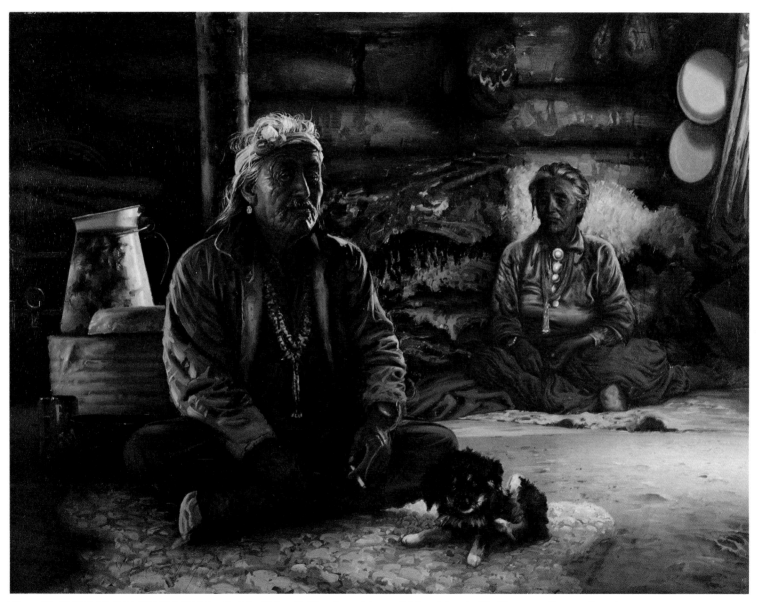

Plate 73. FURCAP IN THE HOGAN, *oil, 36x48 in. Collection: Mr. and Mrs. Morrie H. Zinman, Pennsylvania*

Plate 74. PORTRAIT OF NAVAJO GIRL, AHT-ED PETE,
oil, 18x14 in. Collection: Mrs. John W. Kieckhefer,
Phoenix, Arizona

Plate 75. THE NAVAJO, DUGGAI KLEH, *oil, 20x16 in.*
Collection: First National Bank of Belen, Belen, New Mexico

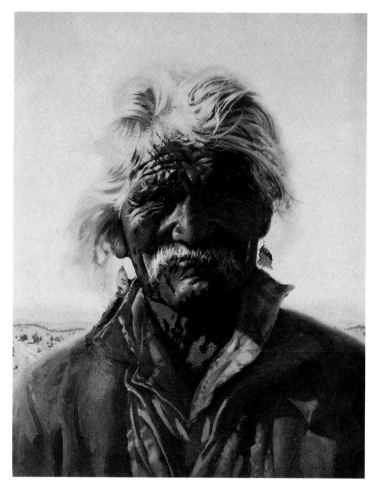

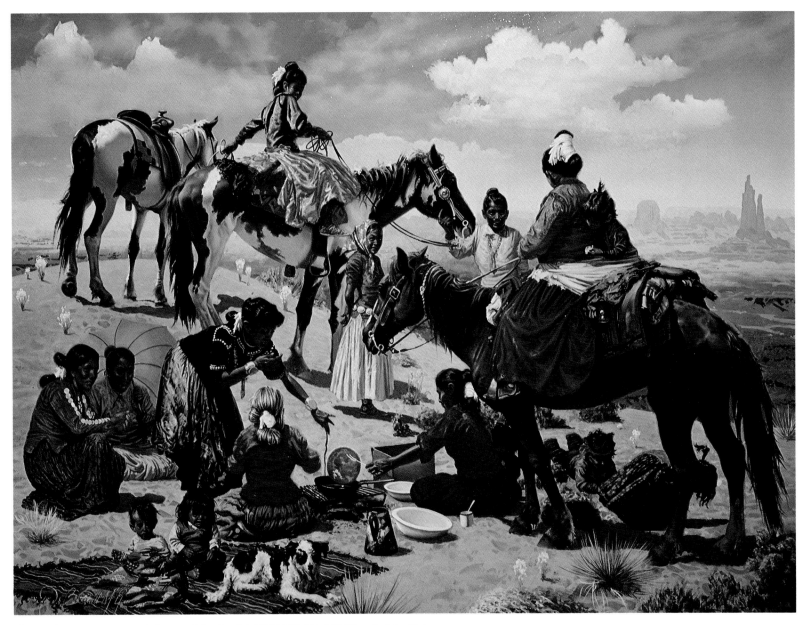

Plate 76. Variation on a Theme: No. 3 of 4, FRYBREAD TIME, *oil, 36x48 in.*
Collection: National Academy of Western Art, Oklahoma City, Oklahoma

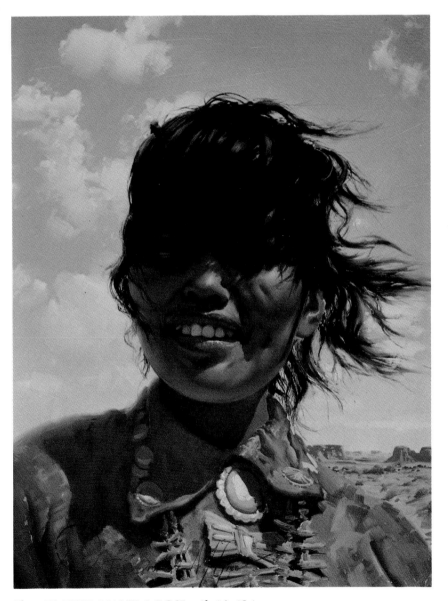

Plate 77. FULL MANY A ROSE, *oil, 14x18 in.*
Private Collection: Palm Springs, California

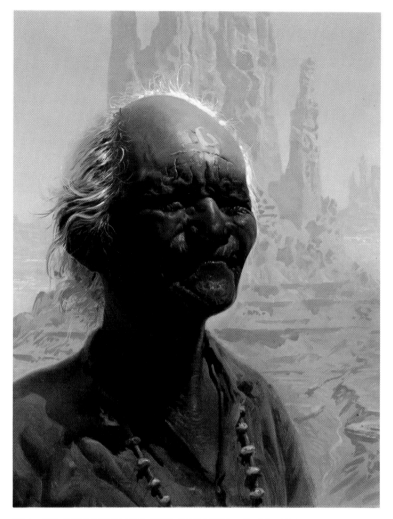

Plate 78. THE NAVAJO, JEH ALKATH, oil, 20x16 in.
Collection: Mr. and Mrs. Don Wenger,
Sabetha, Kansas

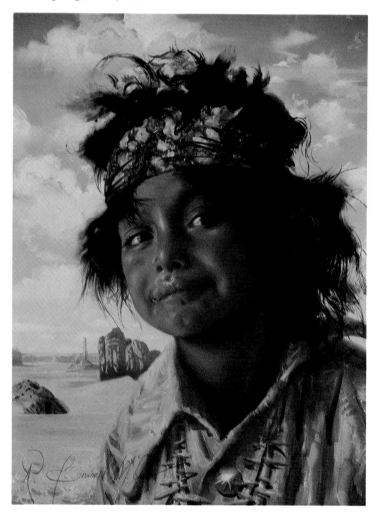

100

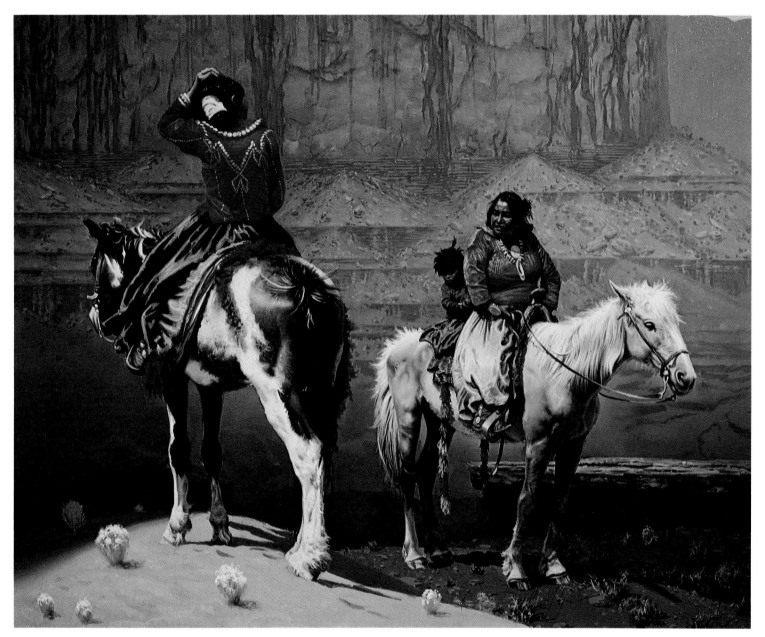

Plate 80. IN THE VALLEY, *oil, 32x40 in. Collection: Mr. and Mrs. Ralph L. Ritter, Scottsdale, Arizona*

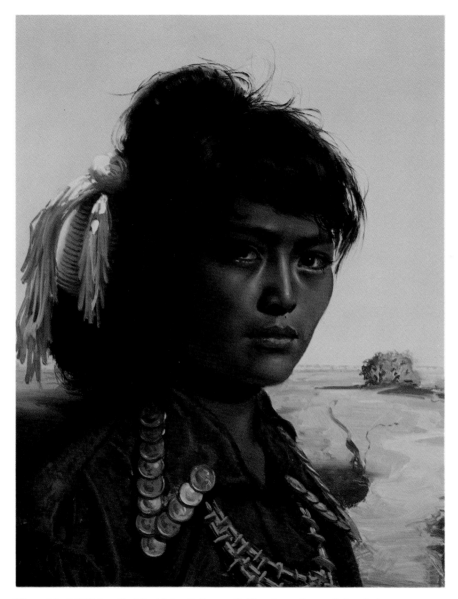

Plate 81. ANNA, oil, 20x16 in. Private Collection: Scottsdale, Arizona

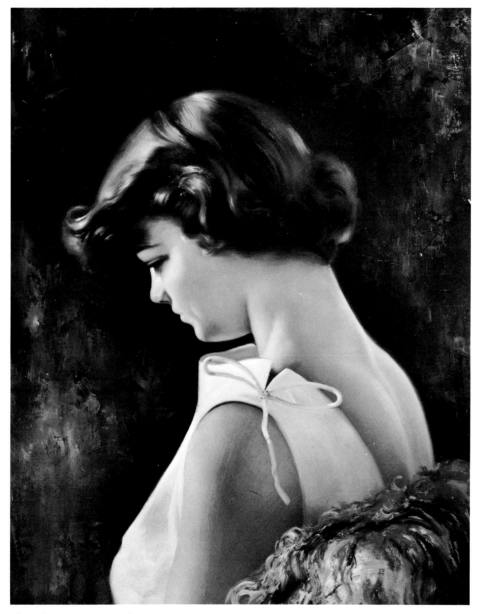

Plate 82. PROFILE, *oil, 24x18 in.*

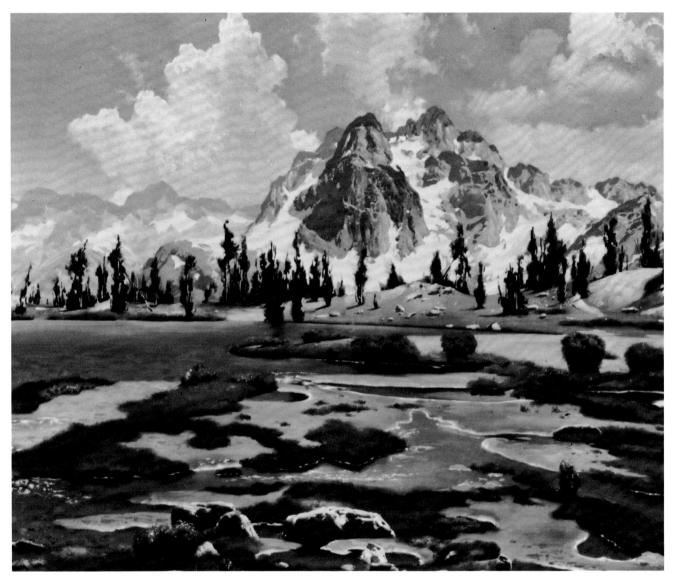

Plate 83. THE INLET, *oil, 30x36 in. Collection: Mr. and Mrs. Carl S. Carlson, Ramsey, New Jersey*

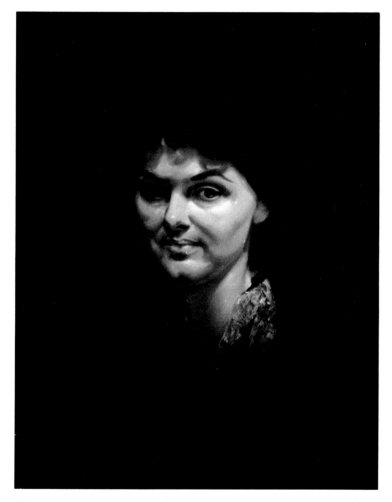

Plate 84. GAIL, A QUICK SKETCH, *oil, 24x20 in.*

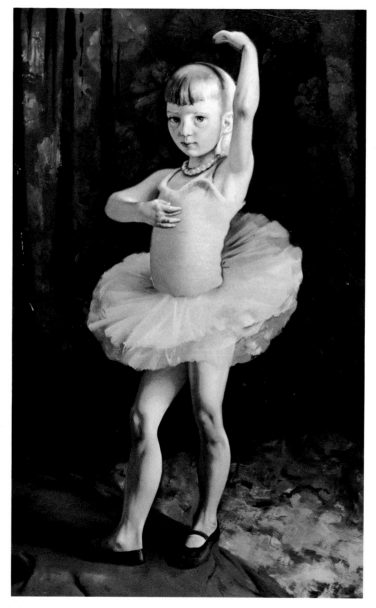

Plate 85. FOURTH POSITION, *oil, 48x26 in.*
Collection: Mr. and Mrs. John A. Mohler, Tucson, Arizona

105

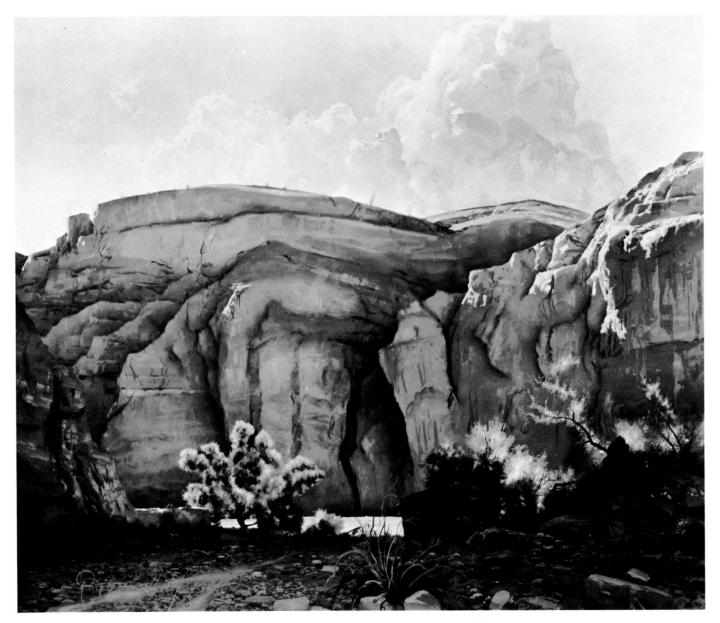

Plate 86. CANTICLE OF JUNE, *oil, 30x36 in. Private Collection: Palm Springs, California*

Plate 87. THE NEWCOMER, *oil, 30x40 in.*

Plate 88. FAMILY GROUP, *oil, 36x30 in.*

Plate 89. SONG OF THE CANYON, *oil, 30x40 in. Collection: Mr. Walter Foster, Tustin, California*

Plate 90. MATTINATA, *oil, 30x36 in. Private Collection: Seattle, Washington*

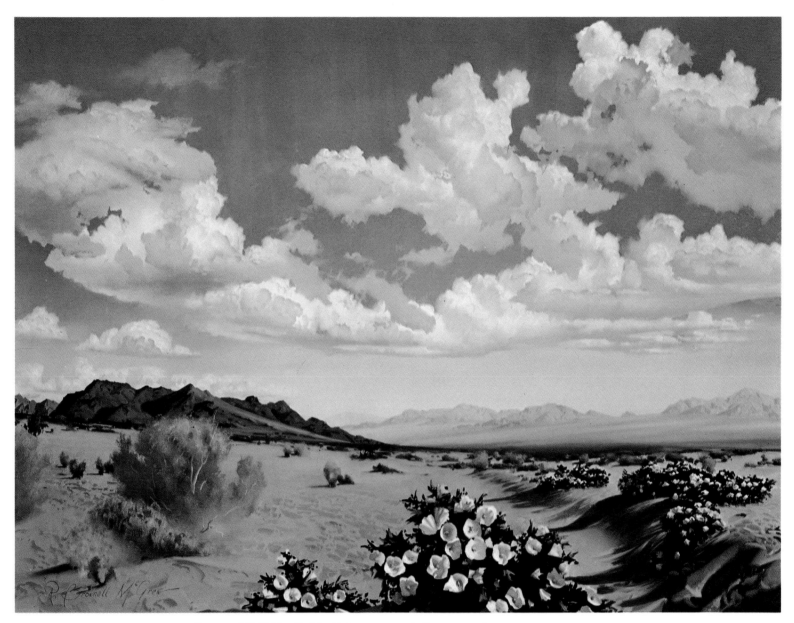

Plate 91. IM DAS HERZEN'S FRÜHLINGSKEIT, *oil, 30x40 in. Private Collection: Phoenix, Arizona*

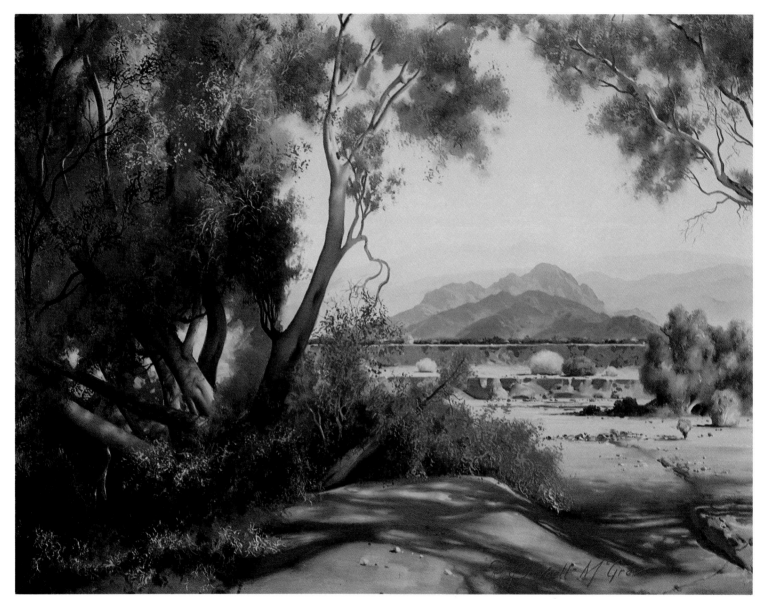

Plate 92. IN THE SMOKETREES, *oil, 30x40 in. Collection: Mrs. Harry J. Friedman, California*

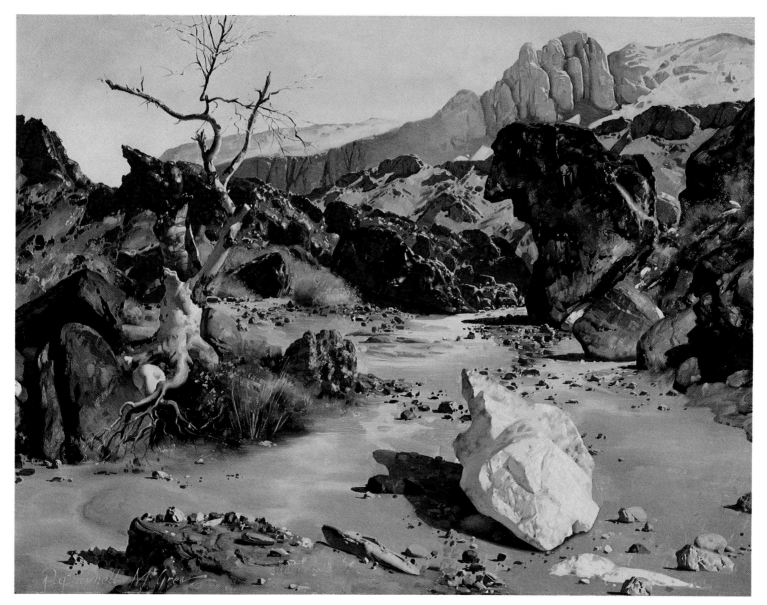

Plate 93. LURE OF THE CANYON, *oil, 28x36 in. Private Collection: Denver, Colorado*

113

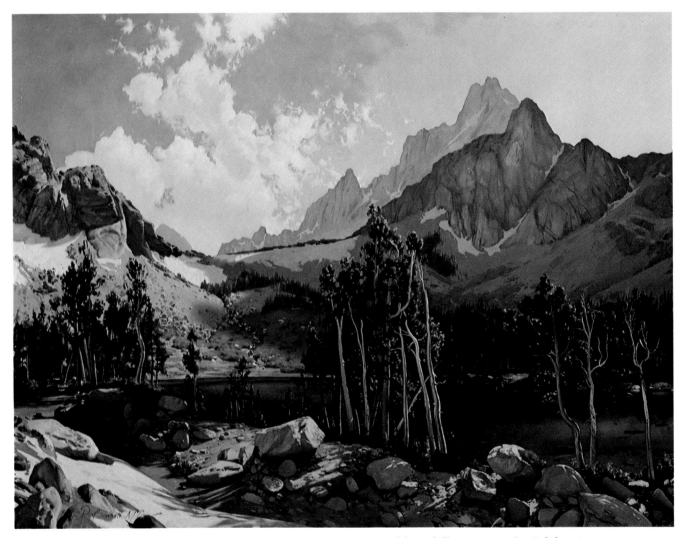

Plate 94. SIERRA LAKE, *oil, 36x48 in. Collection: Mr. and Mrs. Harold Lindell, Buena Park, California*

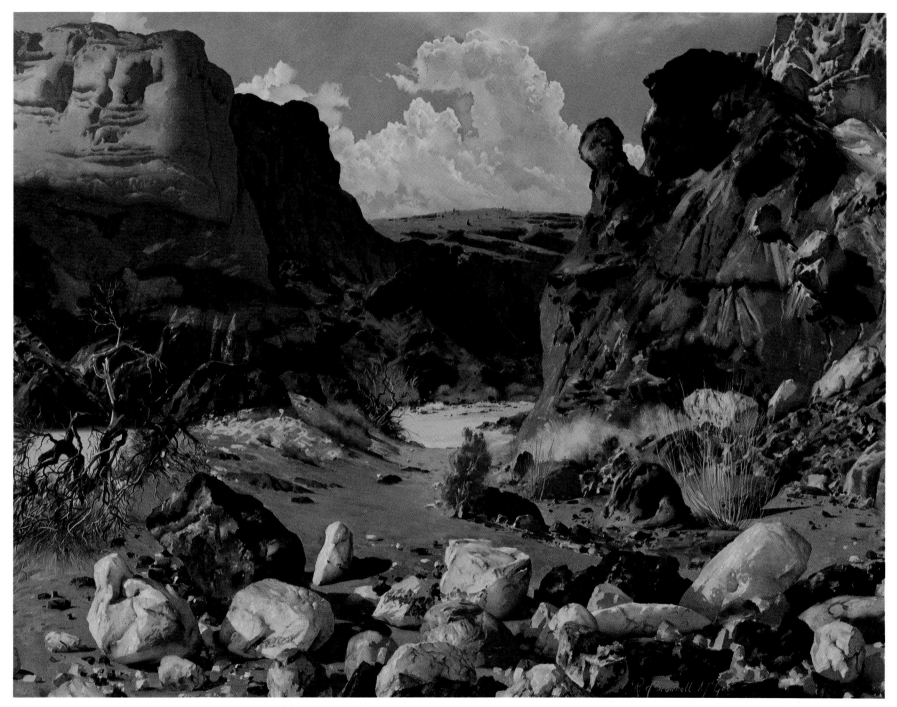

Plate 95. STONE, SKY, AND SILENCE, *oil, 36x48 in. Collection: Ms. Rusty Warren, Phoenix, Arizona*

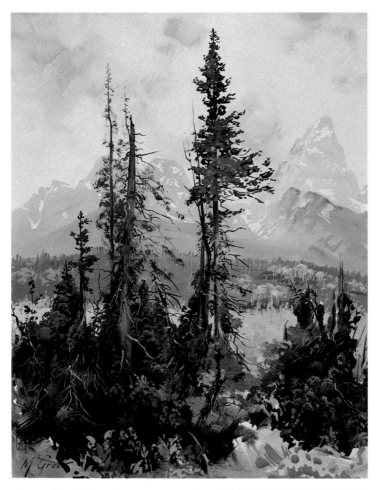

Plate 96. Field Study, RAINY AFTERNOON, GRAND TETONS, oil, 20x16 in.

Plate 97. Field Study, BLOOMING IRONWOOD, oil, 20x16 in.

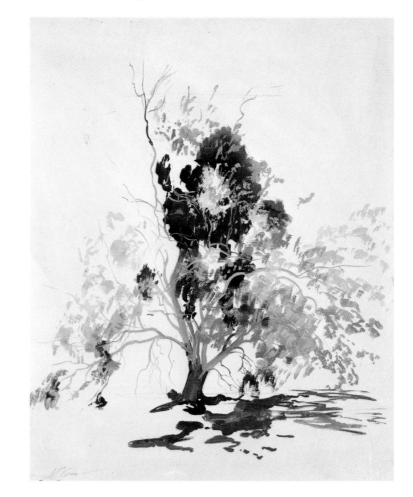

116

Plate 98. Field Study, ROCK COLORS, PAINTED CANYON, *oil, 16x20 in.*

Plate 99. Field Study, LILY PADS, OLYMPIC PENINSULA, *oil, 16x20 in.*

Plate 100. Field Study, OLD ROAD, OLYMPIC PENINSULA, *oil, 16x20 in.*

Plate 101. Field Study, DESERT FOLIAGE, *oil, 16x20 in.*

Plate 102. LATE IN JUNE, *oil, 30x40 in. Collection: Santa Clara University, Santa Clara, California*

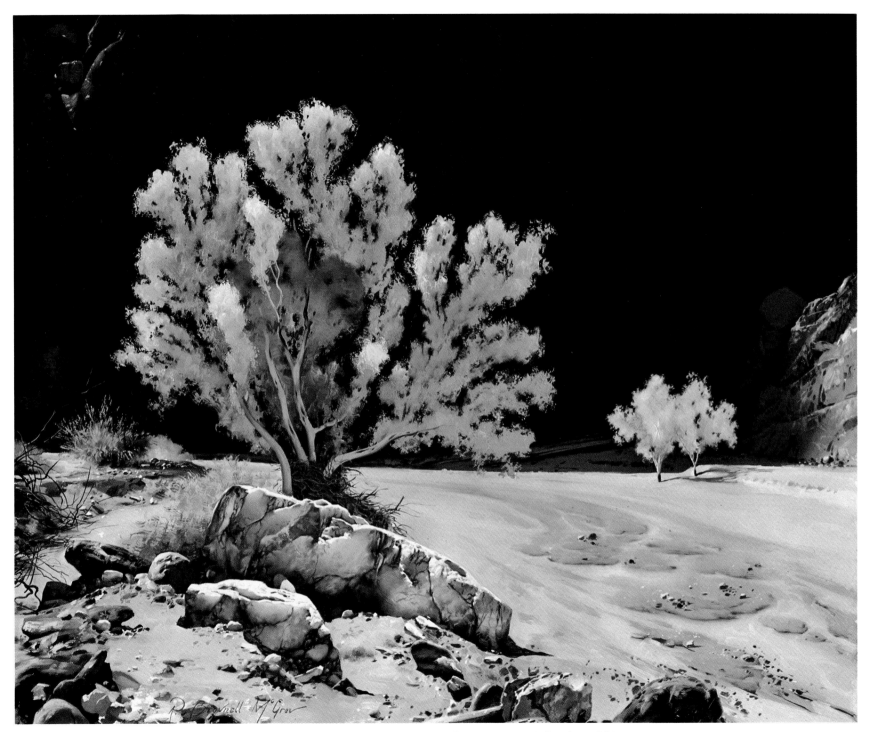

Plate 103. DELIGHT, *oil, 30x36 in. Collection: Mr. and Mrs. Theodore L. Horst, Columbus, Ohio*

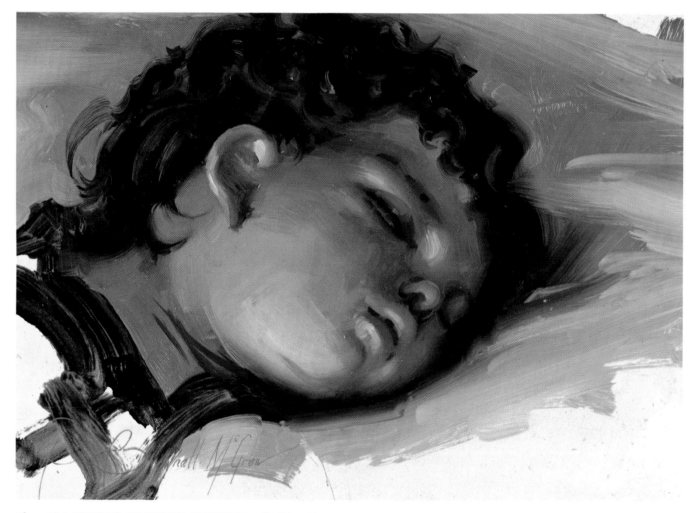

Plate 104. SKETCH OF FRITZL SLEEPING, *oil, 9½x13¼ in.*

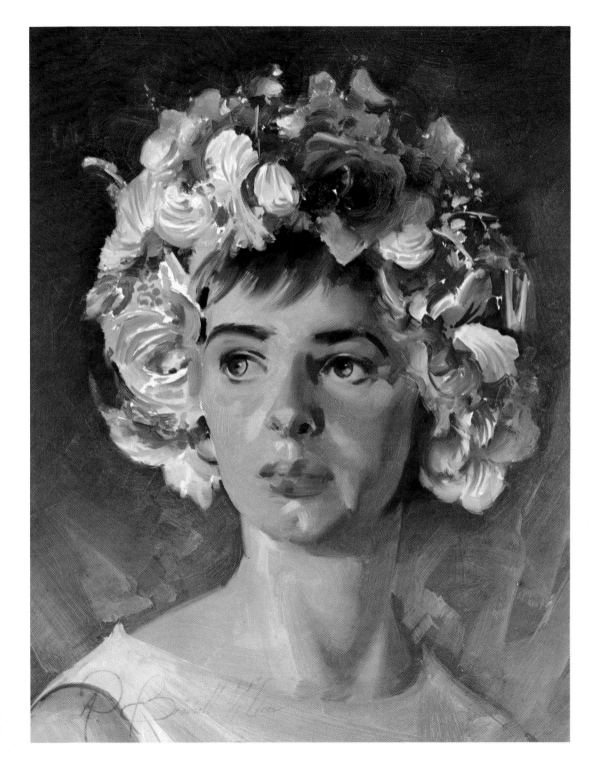

Plate 105. BECKY'S DIOR, *oil, 18x14 in.*
Collection: Mr. and Mrs. John A. Mohler,
Tucson, Arizona

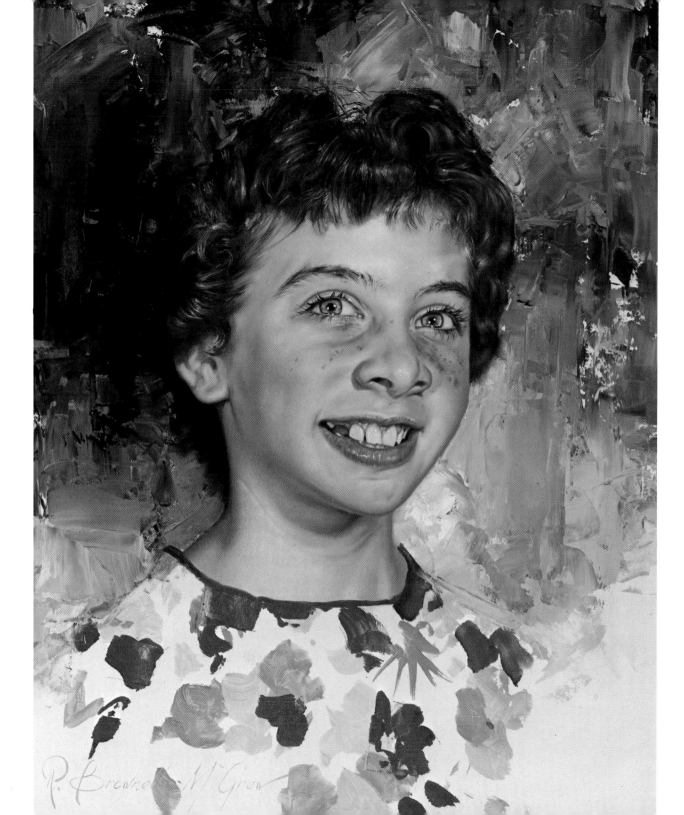

Plate 106. STUDY OF A CHILD'S HEAD,
oil, 20x16 in.

Plate 107. Field Study, AFTERNOON LIGHT, *oil, 14x18 in.*

Plate 108. Field Study, TETON MEADOW, *oil, 14x18 in.*

Plate 109. Field Study, IN THE DATIL HILLS, *oil, 16x20 in.*

123

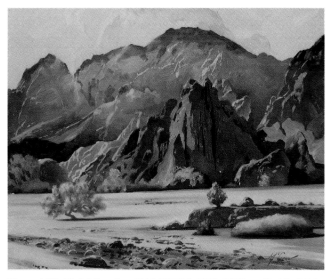

Plate 110. Field Study, CANYON COLORS, *oil, 16x20 in.*

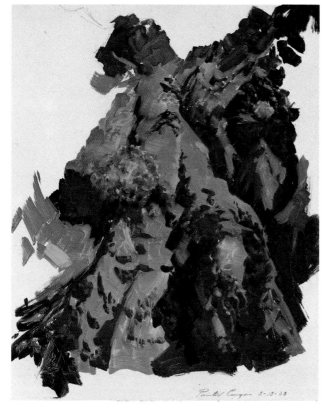

Plate 111. Field Study, PAINTED CANYON, WALL DETAIL, *oil, 20x16 in.*

Plate 112. IN A DESERT CANYON, *oil, 30x40 in. Private Collection: California*

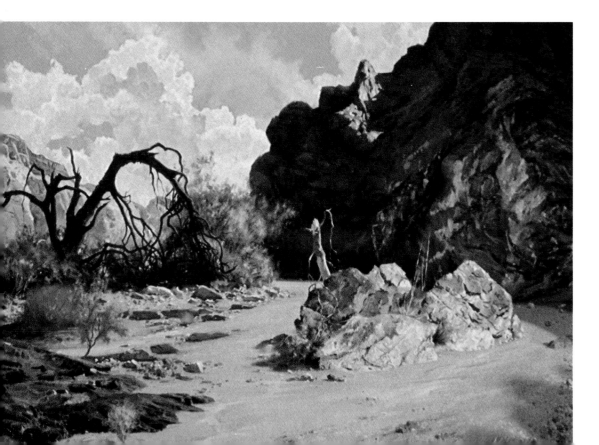

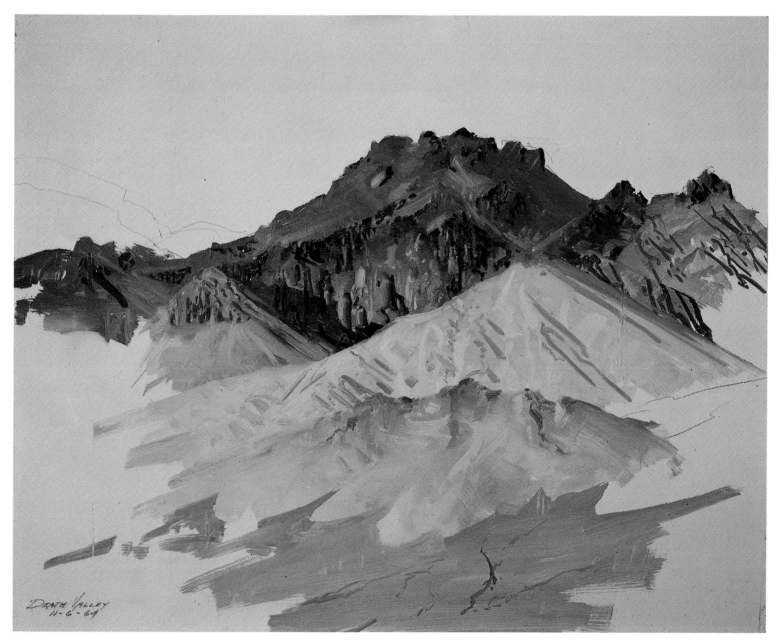

Plate 113. Field Study, DEATH VALLEY, *oil, 16x20 in.*

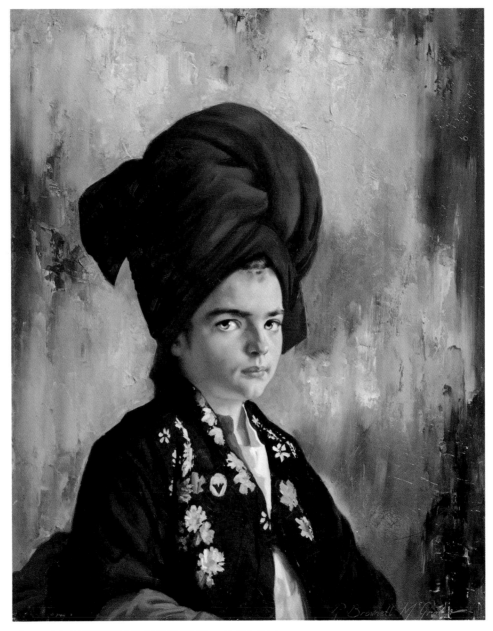

Plate 114. SATURDAY MORNING, *oil, 30x24 in.*

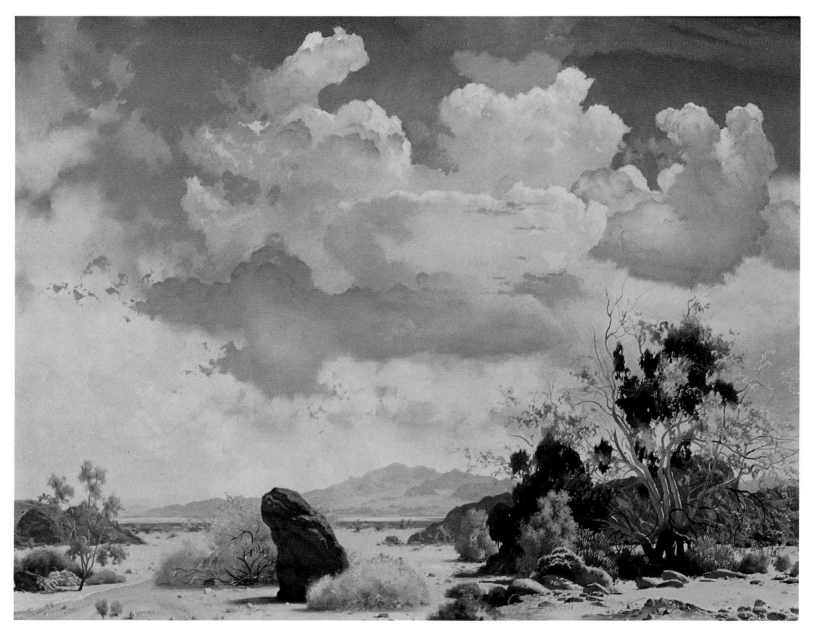

Plate 115. WHEN IRONWOODS BLOOM, *oil, 30x40 in. Collection: Mr. and Mrs. Mickey McArthur, South Laguna, California*

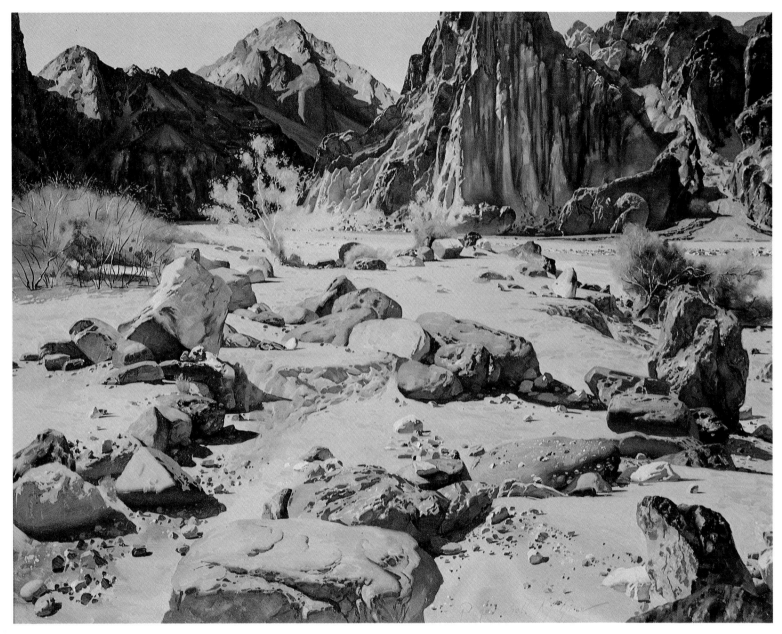

Plate 116. AUBADE, *oil, 35x45 in.*

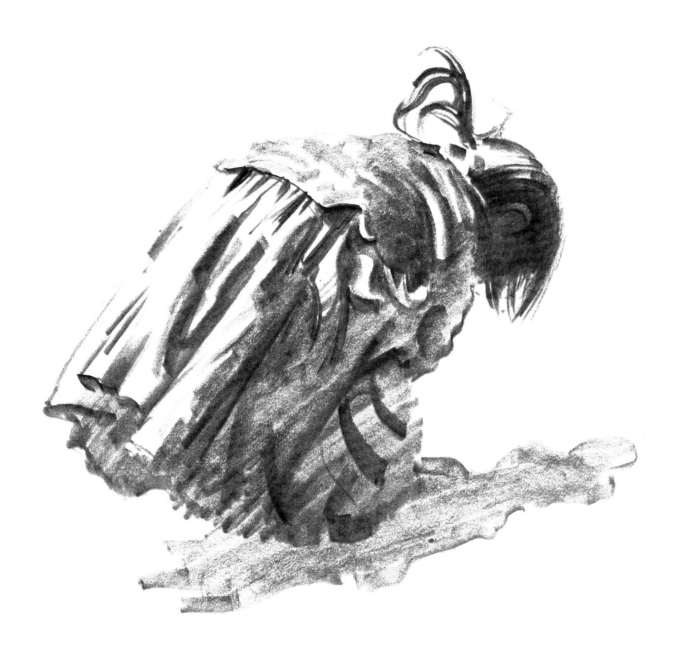

R. BROWNELL McGREW

was designed by David E. Spaw,
photocomposed in Intertype Trump Mediaeval,
and printed on Northwest's Quintessence Dull
by
The Lowell Press, Kansas City, Missouri

The photographers:

Dean Beasom, Burke, Virginia
Birlauf and Steen, Denver, Colorado
Peter Bloomer of Horizons West, Flagstaff, Arizona
Cowboy Hall of Fame and Western Heritage Center,
 Oklahoma City, Oklahoma
Phil Dunham, Norwalk, California
Harbor Photography, Corona Del Mar, California
John Hartley, South Laguna, California
Walter Foster Publications, Tustin, California
Markow Photography, Phoenix, Arizona
Rubins Studio, Midland, Texas
J. G. Schnoor, Ramsey, New Jersey
Taylor and Dull, New York, New York
Harold Waltz, Palm Springs, California